Edited by Timothy Verdon

THE ECUMENISM OF BEAUTY

mount
tabor
BOOKS

PARACLETE PRESS
BREWSTER, MASSACHUSETTS
BARGA, ITALY

2017 First Printing

The Ecumenism of Beauty

Copyright © 2017 by Paraclete Press, Inc.

ISBN 978-1-61261-924-8

Library of Congress Cataloging-in-Publication Data

 Names: Verdon, Timothy, editor.
 Title: The Ecumenism of beauty / edited by Timothy Verdon.
 Description: Brewster MA : Paraclete Press Inc., 2017.
 Identifiers: LCCN 2016052442 | ISBN 9781612619248 (hc with jacket)
 Subjects: LCSH: Aesthetics--Religious aspects--Christianity.
 Classification: LCC BR115.A8 E28 2017 | DDC 246--dc23
 LC record available at https://lccn.loc.gov/2016052442

10 9 8 7 6 5 4 3 2 1

Published by Paraclete Press
Brewster, Massachusetts and Barga, Italy
www.paracletepress.com

Printed in China

CONTENTS

PREFACE

At the end of the Second Vatican Council in 1965, with the cold war still in progress and the atomic threat still active, Pope Paul VI reminded artists that "this world in which we live needs beauty if it would not fall into despair. Beauty," he said, "like truth, puts joy in men's hearts and is a precious fruit able to resist the wear of time, able to unite one generation with another, helping them communicate in shared admiration."[1]

The Pope's words, part of his decades-long effort to renew art in the Catholic Church, struck a chord in many Protestant faith communities as well, opening the way to today's rediscovery of the role of the visual arts in the life of all Christians. And in the new ecumenical age that the Council helped inaugurate, Paul VI's belief that beauty can bridge differences, favor communication, and unite people in "shared admiration" created the hope that art might become an instrument of communion among separated Christians.

This short book is an expression of that hope. Its authors are Catholic, Orthodox, Anglican, and Protestant artists, scholars, and clergy who in 2017 will take part in a symposium organized to commemorate the Reformation, which began when Martin Luther published his 95 theses in 1517. With sessions in Paris, Strasburg, Florence, New Haven (CT) and Orleans (MA), the symposium is promoted by Catholic and Protestant schools of theology and by an ecumenical monastic family, the Community of Jesus, together with the Community's Mount

Tabor Ecumenical Centre for Art and Spirituality in Barga, Italy.

Monsignor Timothy Verdon
Academic Director
Mount Tabor Ecumenical Centre for Art and Spirituality
Barga (LU), Italy

1 "Letter of His Holiness Pope John Paul II to Artists, 1999," quoted at catholic-sacredart.com/letterstoartists.htm, accessed September 24, 2016.

INTRODUCTION

———•———

Timothy Verdon

A
mong traditional Christian practices called into question by sixteenth-century reformers was the use of art in places of worship. Against the Catholic belief that paintings and sculptures in churches have a quasi-sacramental function, Protestants either redefined the role of the visual arts in limitedly catechetical terms or condemned images outright as "idolatrous." In consequence, the hundred years following the publication of Luther's theses saw a polarization of the aesthetics of collective prayer in Europe, as Catholics enriched their temples with ever grander altarpieces and statuary groups, while Protestants stripped away virtually all decoration. Two mid-seventeenth-century views of church interiors, respectively by the Belgian Catholic Pieter Neefs the Elder and the Dutch Protestant Pieter Jansz Saenredam, illustrate the differences (See figures 1–2),[1] showing, on the one hand, the nave and aisles of Antwerp Cathedral encrusted with images, and, on the other, the whitewashed austerity of Saint Odulphus, Assendelft, with totally bare walls.

These works also "illustrate" the theological reasons behind the aesthetic choices. In the Catholic interior, scattered believers are shown moving freely amid paintings of Christ, Mary, and various saints placed above altars, at some of which people attend Mass; in the Reformed church, by contrast, those present all listen to a preacher speaking from a monumental pulpit. Clearly the stratified decoration in Neefs's view reflects

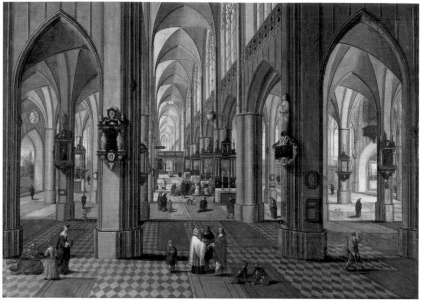

Figure 1

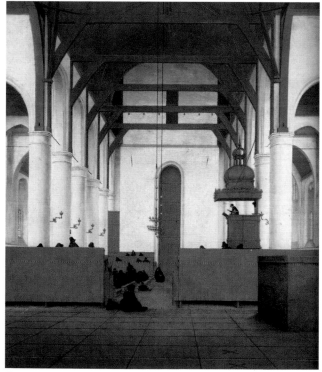

Figure 2

a millennial Catholic liturgical and devotional tradition, whereas Saenredam's stripped Protestant interior focuses all attention on God's word. In its own way, each work recalls the early Christian principle summed up in the phrase *lex orandi, lex credendi* (the rule of prayer determines the rule of faith):[2] the paintings on altars in Neefs's canvas express the Catholic belief in salvation through ecclesial signs, of which the first are the sacraments instituted by Christ; the preacher in the pulpit in Saenredam's painting reminds us that for Luther and other reformers Scripture alone—sola Scriptura—is authoritative for the faith and practice of the Christian.

The question of art had divided Christians in earlier periods too. At the end of the Patristic era Pope Saint Gregory the Great wrote to Serenus, Bishop of Marseille, deploring the latter's destruction of sacred images, which, according to Gregory, were useful in catechizing the illiterate, serving as a *Biblia pauperum*.[3] The issue remained unsettled, and little more than a century after Pope Gregory, in 726 and again in 730, the Byzantine Emperor Leo III emitted decrees prohibiting icons and authorizing their destruction. It was the beginning of the "iconoclastic movement": the struggle of the Eastern emperors of the eighth and early ninth centuries to suppress the cult of icons, in part motivated by the need to respond to the advance of aniconic Islam and by the threat to imperial authority represented by the monastic order, chief promoter of the veneration of sacred images.

The reaction in the Christian West was immediate. In 731, a year after Leo III's second iconoclast decree, Pope Gregory III called a council in Rome to excommunicate

Figure 1: Pieter Neefs the Elder, c. 1578–c. 1661, *Antwerp Cathedral*
Figure 2: Pieter Jansz. Saenredam, 1597–1665, detail, *Interior of the Sint-Odulphuskerk*

those who destroyed sacred images and persecuted image makers—a position reiterated on later occasions as well. After the Second Council of Nicea of 787, however—the Council that reaffirmed the cult of images for both the Eastern and Western churches—, Latin synods at Frankfurt (794) and Paris (825) criticized the Council's conclusions, known in a faulty translation which, confusing the Greek terms for "veneration" (*proskynesis*) and "adoration" (*latreia*), seemed to attribute to images the "adoration" reserved to God alone. Almost eight centuries later, then, one of the sources of the Latin misunderstanding of the Second Council of Nicea's texts, a work known as the *Libri Carolini*, composed in around 790 at Charlemagne's court, was rediscovered and printed by the Catholic scholar Jean du Tillet, Bishop of Brieux and later of Meaux, who had taken part in the Council of Trent. And it was this 1549 edition of the *Libri Carolini*, containing the fatal eighth-century translation error, that came into the hands of John Calvin, one of the most influential Protestant reformers, helping to shape his severe condemnation of images in the context of church life.

Today the sixteenth-century refusal of the visual arts in Protestant houses of prayer—based, at least in part, on terminological confusion—, is no longer considered a significant divisive element. Today, indeed, many Protestant communities commission painting and sculpture for their churches, as if agreeing with the Catholic theologian Joseph Ratzinger, later Pope Benedict XVI, who in 2005 claimed that

. . . from the centuries-long tradition of church councils we learn that the image, too, is a way of preaching the Gospel. Artists of every time have offered to the contemplation and wonder of believers the salient facts of the mystery

of salvation, presenting them in the splendor of color and in the perfection of beauty. This is an indication of how, today more than ever, in our image-oriented civilization, the sacred image can express more than words themselves, thanks to the efficacy of its power to communicate and transmit the Gospel message.[4]

Ratzinger's words, and his reference to "the tradition of church councils," allude to a text written by Patriarch Dimitrios I of Constantinople in 1987 to mark the twelfth centenary of the Second Council of Nicea. Summarizing a thousand years of Eastern Christian thought, the Patriarch wrote that, in the Orthodox tradition, "the image . . . becomes the most powerful form that dogmas and preaching can assume."[5] In a parallel document, also published in 1987, Pope John Paul II cited the chief defender of images in the period of the Iconoclastic Controversy, John Damascene, concluding that "The Church's art must strive to speak the language of the Incarnation, expressing with material elements Him who deigned to inhabit matter and to accomplish our salvation with material means."[6]

In Christ God took human flesh and became visible, that is. Church art is thus not merely a question of didactic images which, in specific circumstances, take the place of the written text. Rather, in Catholic thought, images can touch the innermost reality of a person's life. "Our most authentic tradition, which we share fully with our Orthodox brothers," John Paul II goes on to say, "teaches us that the language of beauty, put at the service of the faith, is able to reach men's hearts and make them know from within Him whom we dare to represent in images, Jesus Christ."[7]

Another Catholic document, *Life Has Become Visible,* a Pastoral Note of the Tuscan Bishops' Conference published in

1997,[8] develops this ecumenical line of reasoning, arguing that in Christ's Incarnation the invisible life of God in fact became visible to men and women, as a New Testament text, 1 John 1:1–2, states, evoking "something that has existed since the beginning, and we have heard, and we have seen with our own eyes; that we have watched and touched with our hands: the Word, who is life. . . ." The New Testament text insists that, in Christ, "that life was made visible: we saw it and we are giving our testimony, telling you of the eternal life which was with the Father and has been made visible to us."

The Gospel, therefore, is not only verbal but also visual. Jesus in fact affirmed that "anyone who sees me sees the Father" (John 14:9), and the Church believes that in Christ's person the whole divine reality shines forth, pervading the Christian Scriptures with irreplaceable *visual* content. To be sure, "no one has ever seen God," as St. John tells us; but the Evangelist immediately adds that, coming into the world, the only-begotten Son "revealed Him" (John 1:18). With his life, death, and resurrection, Christ in fact "narrated" his Father— "illustrated" the Father's love—with a portrait-like fidelity so perfect that the Pauline *Letter to the Colossians* states simply: "He is the image [εικόν] of the unseen God" (Colossians 1:15).

———·———

But if the Word made visible is an "icon," an image, then the importance of manmade images in Christian tradition is not hard to grasp. In the context of liturgical life especially—in Eastern as well as in Western Catholicism—the use of sacred images has served, across the centuries, to manifest the special relationship subsisting, thanks to Christ's Incarnation, between "sign" and "reality," within the economy of sacramental

practice. Indeed, the use of material things in the Church's rites reveals and makes present the vocation of infra-human creation, which is called—together with humans and through humans—to give glory to God. By a mysterious and, at the same time, simple process, this "revelation" becomes part of lived faith, particularly in the context of the Eucharist. Finding God present in matter, Catholic believers are led to grasp the new dignity of every material object, transformed (at least partially) into a "monstrance," just as all human sight is called to ultimately become adoring contemplation.

In a perspective closer to Protestant sensibility, we may add that Christian art puts believers in direct touch with the word of God as it is preached in the Church. The subjects illustrated are, for the most part, biblical in inspiration—to the extent that Saint Gregory the Great held that "what a written text offers to those able to read, the painted image provides for non-readers who look at it."[9] The Second Council of Nicea went so far as to formulate a "scriptural norm" for art made for places of Christian worship, taking the idea from verse 9 of Psalm 47: *sicut audivimus, sic vidimus in civitate Dei nostri*—"as we have heard, so have we seen in the city of our God."

We should further recall that the Bible presents God himself as an artist: *Deus artifex*, subtle creator of masterpieces, such that the psalmist finally exclaims, "How great, O LORD, are your works! You have fashioned all things with wisdom, and earth is full of your creatures" (Psalm 104:24). It follows that men and women too are "creative": made in God's image and likeness (Genesis 1:27), they are artists, and it is in their nature to make beautiful things. In practice, the human drive toward a creativity analogous to

that of God is the context of our creaturely relationship with the Creator.

Indeed, in both the Jewish and Christian Scriptures, when God reveals himself to mortals they often respond by "making something," erecting a monument in permanent sign of the encounter. Thus Jacob, after the dream in which he saw the Lord, "got up, took the stone he had used as a cushion and erected it as a marker" (Genesis 28:10–22). And in the same way, after seeing Jesus transfigured on Tabor, the Apostle Peter wanted to make "three tents": one for Jesus, one for Moses, and one for Elijah, in order to prolong the joy of that moment (see Luke 9:33). In the Bible, human creativity is the most natural response to an encounter with the Creator God.

Such creativity—which can be expressed in many ways: as poetry or music, dance, sculpture, or architecture—is always a "religious" response, through which earth is "bound back" to heaven, and man to God. The stele set up by Jacob at Bethel in fact marked the place where he had seen resting on the earth a ladder whose top reached heaven, and on which God's angels ascended and descended (Genesis 28:12). In like manner, the tents that Peter wanted to set up would have marked a point of convergence: the place where Peter, James, and John saw a man, Jesus, change in his appearance and converse with Moses and Elijah. In short, they saw what had been promised to Nathaniel: "the heavens opened and the angels of God ascending and descending upon the Son of man" (John 1:51). The work of art made to record similar experiences is therefore a work of supreme synthesis: a *scala paradisi* on which opposing extremes are linked, limits overcome, time and eternity joined.

This synthesis comes about in a mysterious way, as every artist knows. It is not part of the ordinary world of human projects and conscious decisions. "Peter and his companions

were overcome with sleep, yet they stayed awake" (Luke 9:32), while Jacob had already gone to sleep and, dreaming, saw heaven and earth joined together. When he awakened, he said: "Truly, the Lord is in this place and I knew it not." Frightened, he exclaimed: "How awesome is this place! This truly is the house of God, this is the gate of heaven" (Genesis 28:16–17).

———·•·———

The creative context is thus numinous: the appropriate spiritual state is a rapture that may be experienced as weariness, exhaustion—as when, their own strength gone, humans abandon themselves and dream, remaining nonetheless awake. One must indeed be disoriented if one would create: must perceive oneself on new and marvelous terrain that seems somehow "the house of God," "the gate of heaven." Like Peter on Mount Tabor, the artist must be overshadowed by a cloud, must be "frightened." Without knowing what he says, he will ask to prolong the moment, to make something— "three tents"—simply because "it is good for us to be here" (Luke 9:32). This is the atmosphere in which art is fashioned and enjoyed: the instant of creative synthesis elicited by the voice from the cloud. In analogy with inspired Bible texts, art exposes us to the shock of an encounter with the supernatural. Art communicates a joy that, from the midst of "sleep" and "fear," still asserts that "it is good for us to be here."

The relationship with God's word in the liturgical context and this link with the wellsprings of human creativity suggest the ultimate purpose of art in the life of the Church: to help establish a contact that can be characterized as "prayer," "contemplation," and "adoration." Even Gregory the Great, defender of the

didactic function of images in a church setting, insists that believers should, in the end, pass from *visio* to *adoratio*.

> It is one thing to "adore" a painting, and quite another to learn from a scene represented in painting what truly we should adore. . . . The brotherhood of priests is held to admonish believers so that these feel ardent compunction before the drama of the scene represented, and thus humbly bow in adoration of the Holy Trinity, which alone is all powerful.[10]

In the same spirit, John Damascene says: "The beauty and color of images stimulate my prayer. They are a feast for the eyes, much as the spectacle of nature spurs my heart to give glory to God."[11]

Invoking the teaching of the Second Council of Nicea, the *Catechism of the Catholic Church* appropriately speaks of sacred images in the chapter on liturgical prayer, entitled "The Sacramental Celebration of the Paschal Mystery."[12] To Nicea II's advice, that "venerable sacred images be displayed in the holy churches of God," the *Catechism* adds that "the contemplation of holy icons, together with meditation on the word of God and singing of liturgical hymns, becomes part of the larger harmony of signs in a celebration, such that the mystery celebrated impresses itself in the heart's memory, and expresses itself in the believer's newness of life."[13]

A description of this, interior process is furnished by Saint Augustine, who tells us,

> The presentation of truth through signs has great power to feed and fan that ardent love, by which, as under some law of gravitation, we flicker upward or inward to our place of

rest. Things presented in this way move and kindle our affection far more than if they were set forth in bald statements . . .; the emotions are less easily set alight while the soul is wholly absorbed in material things, but when it is brought to material signs of spiritual realities, and moves from them to the things they represent, it gathers strength by this very act of passing from one to the other, like the flame of a torch, that burns all the more brightly as it moves.[14]

In the simplicity of a Romanesque country church, in the gentle beauty of a Christ by Fra Angelico or the drama of numerous contemporary works, every believer—and, in truth, every person, whether a believer or not—can grasp meaningful aspects of his or her own spiritual search. Across time, and beyond the cultural and historical divisions that separate us, art discloses an underlying communion rooted in our nature, which is the first gift the Creator makes to us. By inviting those who are near and those who are far off to contemplate New and Old Testament stories and the lives of the saints in mosaics and frescos, stained glass, altarpieces, and statues, we are doing what the Fathers present at the Second Vatican Council had in mind when, in *Gaudium et spes*, they wrote that the Church invites even atheists to reflect on Christ's Gospel with an open mind, and invites them "courteously"—*humaniter* in the Latin text—as one man might talk to another on the basis of their common experience as human beings.

The Church can allow herself such "courtesy" because—as paragraph 21 of *Gaudium et spes* states—she "knows perfectly well that her message is in harmony with the most secret aspirations of the human heart, whenever she

defends the dignity of the human calling and thus restores hope to many who despair of finding a higher destiny." Through the art in our churches, we are thus called to satisfy not only the legitimate requirements visitors may have as tourists, but also "the most secret aspirations of the human heart"—so secret that visitors often do not feel them, even though they are real—: the aspiration to find sense in life, meaning in history, communion with neighbors and with those who are distant in space and time, communion with those who have gone before us, communion with the past.

———•—

To this end, artists themselves should be associated with our commitment to preach the Gospel through images, for artists have always been part of the Church's mission, in an "alliance that is among the most fruitful we have ever made," as Paul VI said. In the help artists and architects can give in understanding historical works and proposing new ones, all can grasp something of the dynamism of human creativity in the service of faith. When architects and artists tell us "why" they projected space in a certain way, or modelled Christ's body in a Pietà just so, or chose a given color to express Mary's joy, they reveal by analogy the structure of our own creative freedom: the infinite ways in which men and women "project," "model," and "color" their lives to better serve God and neighbor.

———•—

The artist "is a vehicle, a channel, an interpreter, a bridge between our religious and spiritual world and society," Paul VI stated. "We greatly honor the artist," he continued, "precisely

because he has an almost priestly ministry parallel to our own. Our ministry is that of God's mysteries, the artist's that of a human cooperation that makes God's mysteries present and accessible."[15]

Notes

1 Pieter Neefs the Elder (1578–after 1656), *Interior of Antwerp Cathedral,* ca. 1640. London, Victoria and Albert Museum no. 854-1894, and Pieter Jansz Saenredam, *Interior of St. Odulphus, Assendelft,* ca. 1649. Amsterdam, Rijksmuseum, SK-C-217.jp.

2 The idea goes back to the fifth-century thinker Prosper of Aquitaine. Cf. M. Righetti, *Manuale di storia liturgica,* 4 vols., Milan 1950: I, p. 25.

3 *Epistola Sereno episcopo massiliensi,* MGH, Epistolae, II, x, Berlin 1957, 269–272.

4 Prologue, *Compendium of the Cathechism of the Catholic Church,* Vatican City 2005.

5 *Encyclique sur la signification théologique de l'icône,* 14.9.1987, n. 15, in *La Documentation catholique* 85 (1988), 323-328; *Regno-documenti,* 5, 1988, 153.

6 Apostolic Letter *Duodecimum saeculum,* 4.12.1987, n.11: *Acta Apostolica Sedis* 80 (1988),241–252; *Enchiridion Vaticanum* 10/2388; cf. John Damascene, *Discourse on Images,* 1, 16, in B. Kotter (ed.), *Die Schriften von Johannes von Damaskos,* III, Berlin-New York, 1975, 73–75.

7 *Duodecimum saeculum,* cit., n. 12.

8 *La vita si è fatta visibile. La comunicazione della fede attraverso l'arte. Nota Pastorale della Conferenza Episcopale Toscana,* Florence 1997.

9 *Epistola Sereno,* cit.

10 *Epistola Sereno,* cit.

11 *De sacris imaginibus orationes,* 1, 27: PG 94, 1268b.

12 *Catechism of the Catholic Church,* 1992, Second Part, First Section, Article 2, pp. 254–255.

13 Ibid.

14 *Epistola* 55, 11,21.

15 Cf. *Insegnamenti di Paolo* VI, Città del Vaticano, 1976, vol. 2, 313–314.

CALVIN AND THE VISUAL ARTS: THE AESTHETICS OF *SOLI DEO GLORIA*

Jérôme Cottin

The rediscovery of Strasbourg at the commemoration of the five hundredth year of the Reformation (1517–2017), and the rediscovery of the Reformation's artistic production, are both essentially centered on the Lutheran contribution. Strasbourg was in fact one of the home cities of the Reformation, but above all of the Lutheran Reformation, formulated in the German language under the inspiration of the reformer Martin Luther. However, it was in that city that the French reformer John Calvin (1509–1564) lived in exile for three years (1538–1541), and it was there that he learned how to direct a Protestant community: the one composed of French Protestants persecuted in the kingdom of France who had sought refuge in Strasbourg, which at the time was a German city.

Furthermore, when we speak of Protestantism's lack of interest in the visual arts we are essentially thinking of Calvin and Calvinism. In order to correct this misunderstanding, I would like to show that Calvin was an enemy not of the arts but rather of *images*, and, to be even more precise, of *devotional images*. He had great aesthetic sensibility, which found expression above all in the poetic and metaphoric power of language.[1] Calvin's aesthetics were entirely oriented toward

God's greatness, in service of the principle of *Soli Deo Gloria* ("to God alone be glory"). In the end they were open to modern aesthetic taste:[2] the tradition that claims him as its founder in fact produced two of the greatest painters of the modern era, Rembrandt and Van Gogh. (See figure 1.)

JEAN CALVIN'S IMAGELESS AESTHETICS

Compared to the reformer Martin Luther (1483–1546), who used art and images in the service of the faith,[3] at first glance the second-generation reformer Jean Calvin cuts a rather meager figure. He never wrote anything positive on religious images, and one tends to think that no one was ever more hostile to the arts than the reformer of Geneva, for whom the religious image was nothing other than the "idol" denounced by the biblical prophets.

Yet it would be a mistake to make an absolute rule of the Geneva-based reformer's negative relationship with images, and this for the following reasons.

- First, the "image" that Calvin denounced was not the modern, humanistic aesthetic image, but rather the image of medieval devotion: the image as support for a piety veined with superstition, which ascribed miraculous power to images, not the image as a *locus* of a contemplation that is aesthetic and indeed also spiritual.

- Second, Calvin's refusal of images was merely the consequence of a more basic refusal, on which he, like the other reformers, focused all his attention: that of the

Figure 1: Rembrandt, 1606-1669, *The Company of Frans Banning Cocq and Willem van Ruytenburgh*, known as *The Night Watch*

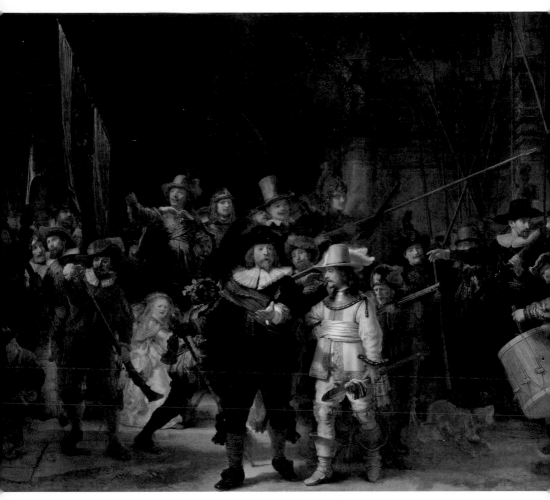
Figure 1

Eucharistic sacrifice of the Mass. In his era people did not make a clear distinction between image and sacrament, the first being considered simply an extension of the second.[4] Thus to the extent that Calvin refused the idea that the Mass is a "sacrifice," he could not but reject its aesthetic transcription in the three-dimensional realism of art. Late medieval theology and church practice had, moreover, done everything possible to blur the boundaries between images and the Eucharist, the image often being simply the visual transcription of the sacrament.

- Third, in his refusal of images in places of worship, Calvin followed his older contemporary, the Zurich-based reformer Ulrich Zwingli. He underscored that the second of the Ten Commandments ("Thou shalt not make graven images . . .")[5] has enduring exemplary value: *all* images are forbidden by the Ten Commandments, not just images receiving human adoration. Calvin was far stricter than Luther in that respect, and for him even an image showing Christ as a man contradicted the biblical commandment. Calvin was not always completely clear on this point, however, and it is uncertain whether he forbade *all* images or only those with an idolatrous character or that might incite to idolatry. In practice he allowed and appreciated secular art—paintings of historical subjects and landscapes—outside the church. He even said that "the art of carving and painting are gifts of God."[6]

Nor is that all. To these observations that make his phobia for images less absolute we should add a significant discovery: the Geneva-based reformer's writings are rich in *aesthetic thought* formulated in relationship to the question of God. Whenever Calvin speaks of God, his texts abound with aesthetic metaphors.

For Calvin, God in all his glory (*Soli Deo Gloria* is the main theme of Calvin's thought) cannot but be *beautiful*. In his writings we discover an aesthetic theology that is highly developed and even modern, which has no parallel among the other reformers. If images are rejected, by contrast the sense of sight is fully developed in his major book, rewritten several times, the *Institution de la religion chrétienne* ("Institutes of the Christian Religion"), and, for Calvin, one who listens is one who sees. Calvin in fact contributes to the elaboration of a new image, but it is a poetic and spiritual one, not plastic or figurative.

Calvin thinks of beauty and relates it to his vision of God—of a God who is glorious, who is the creator, who is spiritual, who is heavenly. Beauty is one of the attributes of the invisible God, and an integral part of his creative act: "In whatever direction we turn our eyes, nowhere is there the slightest part of the world in which there does not gleam at least some spark of his glory."[7] Commenting on Psalm 104, Calvin makes the contemplation of God the very sign of the believer's encounter with him: "Even if God is invisible, his glory is visible nonetheless. When it is a question of his essence, clearly he dwells in inaccessible light; but as long as he shines his light on the whole world, his glory is the garment in which nonetheless there appears to us the one who, in himself, remains hidden."[8] The Geneva-based reformer thus invites us to see God in listening to his Word and in contemplating a creation that has been saved by Grace alone: "God is the Lord of nature, and, in accord with his own will, he uses all of its elements in the service of his glory,"[9] says Calvin, before inviting us to see the signs of God's Grace all around us and within us.

God's beauty is, finally, oriented toward the glorious vision of the Kingdom that is still to come. In Calvin, aesthetics opens the way toward eschatology. Therefore, we should not be amazed to find still more references to spiritual imagery when Calvin speaks

of the Resurrection. God's Kingdom is such a marvelous reality that one can only speak of it in the language of images, "virtually developed in figures," he says. And he adds: "That is why the prophets, since they were unable to express the substance of that spiritual beatitude, described and practically painted it using bodily figures."[10]

There is thus a basic paradox in Calvin, who rejects images in their concrete three-dimensionality yet lays spiritual claim to them as being more fit than even the Word is to express God's glory and our own expectation of the future Kingdom.

As a result, the positions of the two principal reformers, Luther and Calvin, complement each other. Luther advocated for images stripped of aesthetic connotations, and Calvin for an aesthetic experience free of images.[11] Based on the thought of these two reformers, today one can claim for Protestantism a way of thinking about images that is open to aesthetic modernity.

THE AESTHETIC OF MODERNITY AND THE POSTERITY OF CALVINISM

If one examines the fecundity and modernity of these two positions on the image and on art, a considerable surprise awaits us. Beyond any doubt it was not Lutheranism that has had the most productive way of thinking about art, but rather Calvinism. The numerous examples speak for themselves, in particular in Flemish art. Let us cite a few:

- The very many *still-life paintings* with spiritual or moralizing meanings suggest a meditation on the reality of death that

Figure 2: Johannes Vermeer, 1632–1675, *The Girl with a Wineglass*

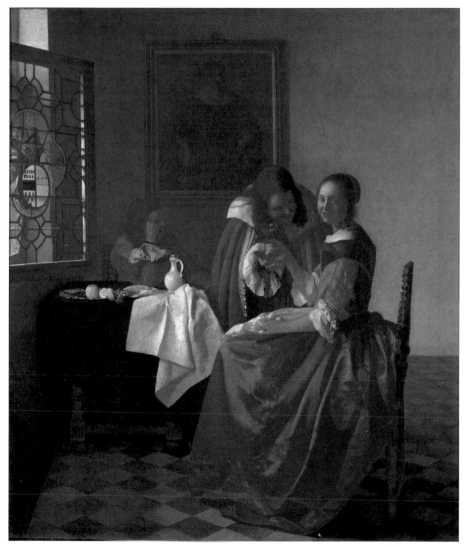

Figure 2

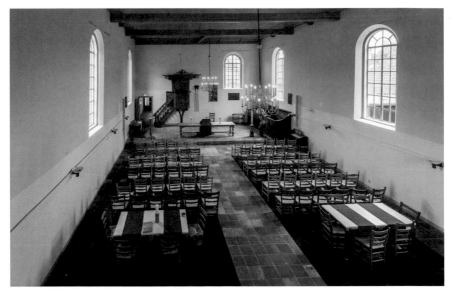

Figure 3

Figure 4

makes all humans equal before God, and on the uselessness of human achievements, or on the imbalance between ephemeral human time and God's eternity.

- *Landscape paintings* (Jacob van Ruysdael) show the beauty and immensity of God's creative action before which humans are but created beings; in fact, the miniscule human person is often lost in the midst of the teeming natural world.
- *Scenes of everyday life* (Vermeer of Delft; Pieter de Hoock) exalt the extremely Calvinist work ethic and a faith lived in the daily routine of family life. (See figure 2.)
- Paintings of *large Dutch church interiors with white walls*, emptied of all their images, show a space that is not "sacred" (a notion that Protestantism rejects) but *spiritual*, full of the presence of the Holy Spirit for the short time in which the community gathers in that space, the Word is heard and the Supper shared. (See figure 3.)

Three of the greatest artists of Western modernity were Calvinist Christians or influenced by Calvinist culture: Rembrandt in the seventeenth century, Van Gogh in the nineteenth (Van Gogh, a minister's son who studied theology and was an "evangelizer" in Brabant, became a painter only because he did not succeed in passing his theology exams). (See figure 4.) Finally, in the twentieth century, the Dutchman Piet Mondrian was deeply affected by the Calvinist tradition he inherited.

With Mondrian, considered the "father" of geometric abstraction, the radical refusal of figurative representation that goes back to Calvin himself, and which was long experienced as a weakness, is shown really to be a point of strength with a rich

Figure 3: Historic Dutch church
Figure 4: Vincent Van Gogh, 1853–1890, *Fishing Boats on the Beach at Les Saintes-Maries-de-la-Mer*

following. To be sure, in his day Calvin could not have imagined it, but his non-representative aesthetics announced and prepared the way for abstract (or non-figurative) art that has played the main role in contemporary artistic creation for more than a century. From its beginnings, abstract art is also—as we can never sufficiently insist—the vehicle of an intense spiritual quest (Kandinsky, Malevitch, and Manessier in Europe, Mark Rothko or Barnett Newman in the US).

In the Calvinist (or "reformed") cantons of Switzerland, the renowned artists touched by Protestant culture are many: we should cite the names of Ferdinand Hodler, Eugène Burnand, and Albert Anker in the nineteenth and early twentieth centuries. A little later in the twentieth century the painter Paul Klee, the sculptor Alberto Giacometti, and the architect (but also painter) Le Corbusier were shaped by the Calvinist atmosphere of their birthplaces: respectively Berne; the Bregaglia Valley in the Canton des Grisons; and La Chaux-de-Fond. Even if most of these artists abandoned any personal profession of faith, they remained affected by their Calvinist Protestant culture.

Today many men and women are searching for a religious spirituality through art. Calvin's reticence about expressing God using human forms of representation, and his attraction for visual metaphors (the fountain, the sun, light), express God's greatness and his unfathomable goodness, and could encourage these "contemporary seekers of God" to pass from artistic metaphors to biblical ones—from the contemplation of artworks to the meditation of biblical texts.

Notes:

1 A. Dyrness, *Reformed Theology and Visual Culture. The Protestant Imagination from Calvin to Edwards,* Cambridge, 2004; Jérôme Cottin, "Ce beau chef-d'œuvre du monde." L'esthétique théologique de Calvin, *Revue d'Histoire et de Philosophie Religieuses,* 89 (2009/4), pp. 489–510 ; C.R. Joby, *Calvinism and the Arts; a Re-assessment,* Leuven-Paris-Dudley, 2007.

2 Jérôme Cottin, Article: "God IX: Visual Arts," *Encyclopedia of the Bible and its Reception* (EBR), *Vol. 10,* Berlin-New York, De Gruyter, 2015, col. 419-426.

3 Jérôme Cottin, "Luther, théologien de l'image," *Etudes Théologiques et Religieuses* 67, (1992/4), pp/ 561-568.

4 Tobias Frese, *Aktual- und Realpräsenz. Das eucharistische Christusbild von er Spätantike bis ins Mittelalter,* Berlin, Gebr. Mann Verlag, 2013.

5 Exodus 20:1-4; Deuteronomy 5:6–9.

6 Jean Calvin, *Institution de la religion chrétienne* (1559), I, 2, 12. We find the same expression again in his *Commentaire de Genèse* 4,20 (1554).

7 Jean Calvin, *Institution de la religion chrétienne,* (1541), chapter 1, 203–4.

8 Jean Calvin, *Commentaire sur le Psaume 104* (CO 32, 85).

9 Jean Calvin, *Institution de la religion chrétienne* (1559), IV, 14, 18.

10 Jean Calvin, *Institution de la religion chrétienne* (1559), III, 25, 10.

11 This is the thesis I defended in my book *Le regard et la Parole. Une théologie protestante de l'image* (Genève: Labor et Fides, 1984).

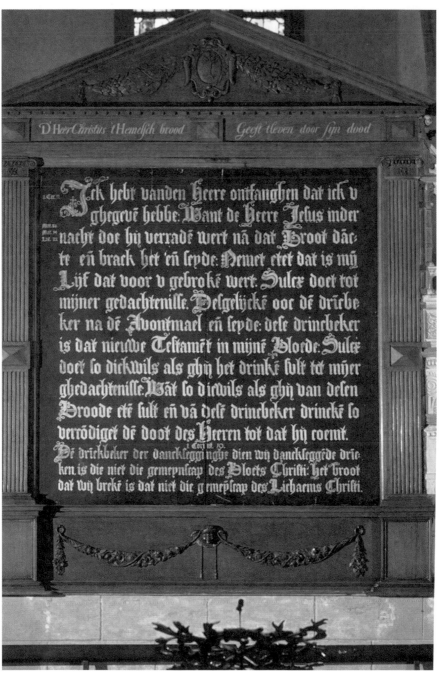

Figure 1

OPENING THE PROTESTANT CHURCH TO BEAUTY

William Dyrness

In 2017 Christians take time to look back 500 years to the beginning of the Protestant Reformation—marked by Martin Luther's nailing his 95 theses for debate on the Wittenberg church door. Why should North American Protestants take time to reflect on the significance of this event and all this would entail over the century that followed? I argue they should do this because, contrary to what they might believe, the events of that century continue to deeply mark their faith and its practice, especially what Timothy Verdon has called their "aesthetics of collective prayer." Perhaps such reflection would lead to an understanding not only of why visual art is often missing from the worship spaces of Protestant churches, but also why their collective prayer has taken the particular aesthetic shape it has. Such historical reflection might do something else that Protestants need: it might encourage the recent recovery of the rich Christian artistic heritage that was often dismissed in Reformation polemics.

Let me consider the first proposal: why, despite the barrage of images present in contemporary culture, do Protestants spend so little time reflecting on the visual dimension of their worship space and of their collective prayer? To answer this question, one must

Figure 1: Under the influence of Calvinism, the words of Scripture themselves became an image in seventeenth-century Dutch churches.

reflect on the dramatic events of the sixteenth century, especially the changing character of the worship space. Timothy Verdon has contrasted the worship space of the medieval world where believers moved freely among paintings and images of Christ and the saints, with the Reformed church where believers gathered to sit in pews and listen to a sermon delivered from an impressive (and often beautifully decorated) pulpit. What was previously a space for rich visual engagement and contemplation, became a place of listening, learning, and (often equally engaged) personal reflection.

The focus in Reformed churches came to rest not only on the preaching and interpretation of Scripture, but also the believers' response of prayer and singing—the lively Psalm singing of believers in Calvin's Geneva was well known. But because of these changes the *look* of the space became less important. In fact, in a little-known instruction to church elders, Calvin decreed that outside of worship hours the church is to be locked, so that, Calvin said, "no one outside the hours [of the service of worship] may enter for superstitious reasons." He went on, "If anyone be found making any particular devotion inside or nearby, he is to be admonished; if it appears to be a superstition which he will not amend he is to be chastised."[1]

Aside from accounting for the fact that Protestant churches are still mostly locked during the week, in contrast to Catholic or Orthodox worship spaces that are mostly open to the faithful, there are some important implications to this instruction that continue to shape the Protestant imagination. First, worship space is no longer a place for specific devotion that involved (it was assumed) the images that had proliferated in the medieval

Figure 2. The Protestant tradition has encouraged congregational singing.

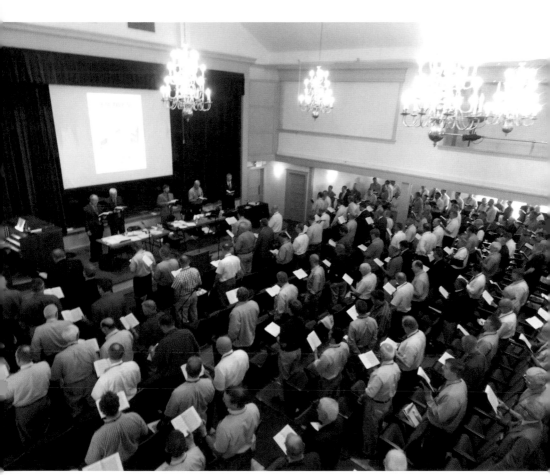

Figure 2

church—Calvin and the other reformers were insistent that those visual cues were no longer necessary for true worship. There is more to be said on this front than we can address here, but the reformers did not necessarily condemn all use of images for private devotion, or even, permanently, from the space of worship. Luther disagreed with the iconoclasts who condemned all imagery in the church. According to him, the iconoclasts did not realize that the real danger of idolatry was a deeper matter than simply placing images in the church. Rather, Luther noted, idolatry sprang from the mistaken intentions of the person who places "an image in a church [and] imagines he has performed a service (*einen güten Dienst*) to God and done a good work (*gutes Werk*), which is downright idolatry (*Abgotterei*)."[2] Calvin for his part often spoke highly of art as of music, but felt that for his period and time images and ceremonies in the church had become problematic. In the *Institutes* in the section on church order, after he has complained about the superstitions that distracted worshipers from attending to the preached word, Calvin explained: "This present age offers proof of the fact that it may be a fitting thing to lay aside, as may be opportune in the circumstances, certain rites that in other circumstances are not impious or indecorous."[3] In short the pressing needs for reform called for drastic measures with respect to images, and, as a result the space of the church was reconceived as a place for the presentation of the word.

(See figure 1. The space of the church was to focus on the word of Scripture.)

Notice why this is so. When outside of regular worship hours, the church is locked, the events and practices of that corporate

Figure 3. Seventeenth-century Dutch art, influenced by the Reformation, featured creation as a theatre for God's glory. Jacob van Ruisdael, 1628–1682, *Three Trees in a Landscape*

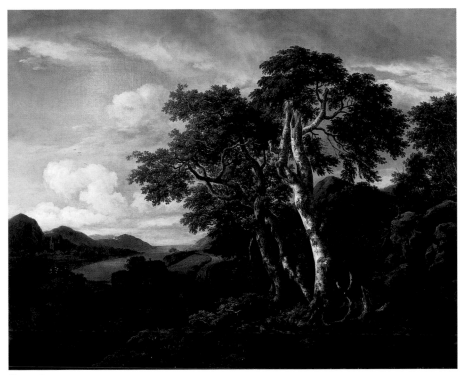

Figure 3

worship are given greater significance. What gives life to the space of the church, Calvin insisted, was not the sacred images of saints, but the faithful preaching of Scripture, the careful performance of the sacraments of Eucharist and Baptism, the singing of the Psalms, and, for the children, the weekly catechetical instructions. These practices were to form their collective worship life and animate their corporate prayers. But it would be wrong to imply these performances were devoid of all aesthetic considerations; rather, they led to a different aesthetic focus that featured the beauty of language and of music as privileged carriers of authentic spirituality. And for the last 500 years the focus of Protestant worship has continued to be on the preaching of Scripture and (often) on the lively singing of their corporate prayers. (See figure 2.)

Thirdly, this "locked space" has had enormous implications for believers' personal and private devotion, and the look and feel of this. The reforms of the late medieval period, fostered by the mendicant movements, the writings of the mystics, and the rise of devotional images, had fostered practices that encouraged the believer's personal engagement in prayer and meditation. Much of the enduring art and artifacts of that period—the devotional images, rosaries, and prayer books—were created to serve such purposes. But when the church was locked outside of corporate worship, a revolution of personal devotion was being signaled. When we hear Calvin's instructions to lock the church, we are tempted to ask: "But wait, what if we want to come into the quiet of the church during a busy week to reflect on the sermon and pray?" The response of the reformers—both Luther and Calvin—was consistent: one does not have to enter a church to pray; in fact, one should pray at home with the family, in the blacksmith shop while working, or while traveling. All these places were to be potential places of devotion. But again, it would be wrong to assume that this diminishes the importance of all art and

aesthetics. Rather it encourages art (and drama and literature) that focused on the spirituality of everyday life, and God's presence (or absence) there. One can argue that this aesthetic finds its highest expression in seventeenth-century English literature and, in visual art, in the Dutch landscape. (See figure 3.)

But of course, with this new geography of devotion and worship, something has also been lost—suggesting my second hope for this five hundredth anniversary. Locking the church may also be taken as a metaphor for a whole medieval world of art, architecture, spiritual practices, and even social order that was now being rejected. Recent scholarship, both Protestant and Catholic, has come to focus on the gulf that was created by, especially, the Calvinist reform and its influence on Britain and America. At about the same time Calvin was issuing his instructions to lock the church, in England, the Calvinist-inspired Elizabethan Settlement (1559) indicated a parallel, and unsettling, uprooting of medieval corporate culture. The Settlement called on clergy to "take away, utterly extinct (sic) and destroy all shrines . . . pictures, paintings and all other monuments . . . so that there remain no memory of the same in walls, glasses, windows or elsewhere within their churches or houses."[4] Eamon Duffy notes the ways this inclination eliminated not only a range of medieval images and devotional practices, but also dismantled the entire communal social structure of that period.[5]

Here a question must be posed to contemporary Protestant pastors and leaders: Why, after 500 years, when Protestants are learning again from medieval practices—praying the labyrinth, practicing *lectio divina,* and embracing Ignatian spiritual practices and retreats—are their worship spaces, and their corporate prayer, so often devoid of visual beauty? There are exceptions of course, and we can hope this anniversary year will celebrate these exceptions. (See figure 4.)

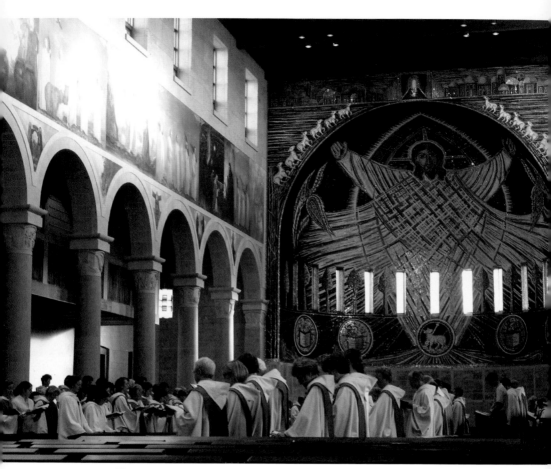

Figure 4

We can hope this year of celebration will encourage this welcome reconnection with our shared Christian artistic heritage.

Many Protestants have read the documents of Vatican II that noted the church has "always been the friend of the fine arts and has continuously sought their noble ministry with the special aim that all things set apart for use in divine worship should be truly worthy, becoming, and beautiful, signs and symbols of heavenly realities" (SCL, 122). They have read the "Letter to Artists" of St. John Paul II, which notes "the Church needs art. Art must make perceptible, and as far as possible, attractive, the world of the spirit, of the invisible, of God" ("Letter to Artists" 12). Since the Reformation Protestants have embraced the beauty of the word and of music in their collective prayer; this year reminds us that now it is time to open their worship spaces to visual beauty as a sign of God's presence.

Notes:

1 Calvin, *Theological Treatises,* ed. J. K. S. Reid (London: SCM Press, 1954), 79.

2 *Luther's Works,* eds. Jaroslav Pelikan et al (St Louis: Concordia Publishing House, 1955), Volume 51, p. 84 (WA 10III:31).

3 *Institutes of the Christian Religion,* ed. John McNeil. Trans. Ford Lewis Battles (Philadelphia: Westminster Press, 1960), IV, 10, 32.

4 Eamon Duffy, *Saints, Sacrilege and Sedition* (New York: Bloomsbury Academic, 2012), 240.

5 Brad Gregory's characterization of this break is even more damning. *The Unintended Reformation: How a Religious Revolution Secularized Society* (Cambridge, MA: Harvard UP, 2012).

Figure 4. The Church of the Transfiguration at the ecumenical Community of Jesus in Orleans, Massachusetts, demonstrates how Protestants are joining with other traditions to recover their joint aesthetic heritage.

FOR NOW WE SEE THROUGH A GLASS, DARKLY

Susan Kanaga

The daily practice for every artist is expressing concepts, emotions, and realities through the vehicle of their work. In essence, the artist is compelled to create images that speak without words; he or she has a responsibility to express beauty and truth. For some, this could mean accessing memories or reactions to past and present day occurrences. All artists create from their imaginations, inner thoughts, and desires and beliefs particular only to them. For the Christian artist, the scope is narrowed and grounded on one principle, their faith.

We all come from different faith traditions, and the way in which I approach fabricating sacred art stems directly from my childhood. I was raised in the Reformed tradition, specifically the Episcopal Church. I have many fond memories of worshiping in St. Andrew's Episcopal Church in Kansas City, Missouri, where I was baptized, confirmed, and married, and yet I always felt as if "something" was missing. As a senior in high school, I had the opportunity to visit Rome, and there, I finally understood what that "something" was: imagery! Aside from stained glass windows, my childhood church held little other sacred art.

As a child with a vivid imagination I filled the imagery void within my mind. As the word of God was spoken during services, I would imagine its shape and color. I could actually see words such as "incarnation," "transfiguration," and the phrase "so great a cloud of witnesses." Angels took form and hovered in the

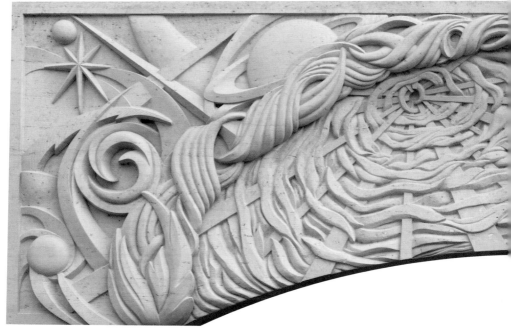

Figure 1

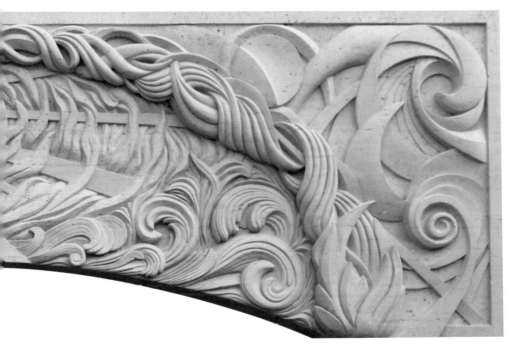

sanctuary; biblical narratives and the word of God came alive! I began to understand image and word carried equal weight; in my mind they were married. Little did I know my visit to Rome and to the churches I saw there, where I beheld the power of sacred art and my personal desire to flesh out the word of God, would someday change my life. Looking back on my early faith walk, I believe God planted within me an ecumenical seed that has grown slowly over the years. My desire to see the word of God speak through sacred art within a worship space and through a personal art practice has been answered; the void has been filled to overflowing.

For the last 33 years I have lived as a vowed member of the Community of Jesus, a modern-day abbey in the Benedictine tradition. The Church of the Transfiguration, the focal point of all activities within the community, is filled with images. From the mosaic pavement to the frescoed clerestory, all of the stunning artwork within the worship space amplifies the word of God and undergirds the liturgy.

In 1999, with great joy, I received a design commission for the sculpture of the seven-ton limestone exterior lintel of the Church of the Transfiguration. Working with Master Sculptor Régis Demange, I was given the artistic challenge of interpreting in two-dimensional form the words of Genesis 1:1–2, "In the beginning God created the heavens and the earth. The earth was without form and void, and darkness was upon the face of the deep; and the Spirit of God was moving over the face of the waters." The design was later realized three-dimensionally in stone sculpture by Régis. (See figure 1.)

Figure 1 (preceding page): Susan Kanaga, design; Régis Demange, sculpture, atrium lintel "Ruach," the Church of the Transfiguration
Figure 2: Susan Kanaga, born 1954, *Yes* triptych
Figure 3: Susan Kanaga, *Journey* triptych
(Pages 28–29) Figure 4: Susan Kanaga, *Messengers*

Figure 2

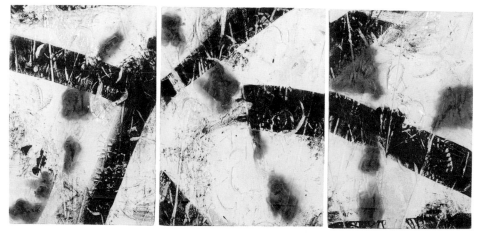

Figure 3

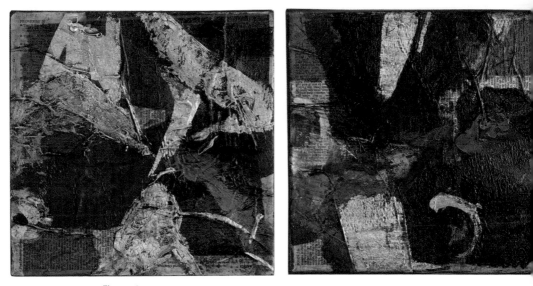

Figure 4

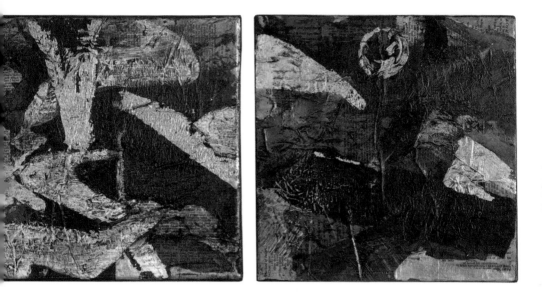

In 2006, Régis and I again collaborated, designing and fabricating a creation cycle for the ten column capitals of the Church of the Transfiguration's atrium; these were further inspired by Psalm 104. Through much prayer and meditation on the Scriptures, words such as "without form and void" and *ruach* took shape in my mind, as did God's "let there be" commands. Humbled by the task and the immensity of the project, I knew in my heart this commission was a gift of God, an answer to prayer. Sacred art was now my vocation.

My present-day studio practice continues to deal with the intangible themes of faith, hope, and love. These eternal mysteries both interface with and challenge my Christian beliefs and my practice of painting. I've come to see these concepts as existing on the other side of reason, and sometimes I find them (more often than not!), difficult to understand. However, I believe there is a feeling of knowing, a feeling of connection, a communion with the indefinable and invisible through the act of painting that, when coupled with prayer, conveys an essence without words.

However, getting myself to the point where there is a connection with other worldly mysteries is no easy task. Just as I must paint every day, I must also pray every day. Both are disciplines, oftentimes difficult disciplines. But in my experience they are inseparable in that they allow "me"—my *self*—a chance to get out of the way. Painting and prayer allow me to put God first and also humbly to receive the grace of hearing the Holy Spirit clearly, not tainted by self. The Christian artist is not only God's servant but also a servant of the artwork the Holy Spirit inspires.

Ideas come to an artist through many channels. Whether through Scripture, anointed inspiration, or a thousand other ways (I believe if God is urging the artist in a certain direction, he doesn't stop with one mode of inspiration!), something always happens within the artist's mind when bombarded by the Holy

Spirit. Plato described this creative process best with his words "divine madness." The Christian artist has to let go of that which is rational, that which is feared, and listen with selfless ears for the truth; one needs to sit in humble silence, open to the Holy Spirit. My personal experience reveals that then and only then can I begin to hear and see what the work needs. When an idea comes, it is my job to be obedient to fleshing out its truth. I have to say "yes" to what I believe God has given me, because as an artist I am a birth giver. I'd like to think my small "yes" echoes the response of the Virgin Mary to the Archangel Gabriel. Putting my reasoning, my traditions, and my rules aside to hear God's inspiration allows me to serve the work. I find when I allow this to happen, the work knows more than I do.

Two questions in particular drive my studio practice: First, what is the presence of absence? And second, how does one create a formless form? I have never completely answered these questions, nor do I expect to; they serve to focus my work and prompt me to prayerfully ask more questions and to be continually challenged. These queries provide a door into the unseeable, for the faith-inspired imagination to explore.

In wrestling with the unanswerable, I have found abstraction, abstract sacred art, the best language to navigate the indefinite. Abstraction provides a wide range of possibilities to convey ideas central to my work, such as angels or the Word made flesh—concepts which are themselves abstract. It is the perfect style to utilize when exploring the spiritual, when exploring ideas that carry a moral dimension. I believe abstract sacred art, driven by the Holy Spirit, allows the artist to communicate beauty and truth and bridge the gap between faith traditions. Abstraction provides a nonthreatening way into the artwork, leaving space for the viewer to interject his or her own personal interpretation, experience, and meaning. Abstract sacred art provides a deciphering tool for

viewers from all faith traditions to be in relationship with the work; it allows artwork the freedom to speak to everyone.

I am drawn to pure abstraction, and all of my work is grounded on this concept. The triptych *Yes* is a nonrepresentational exploration on canvas of the three vows taken by members of the Community of Jesus when they make their profession. (See figure 2.)

I employed a wide range of colors, texture, and line that I felt were symbolic of the Benedictine commitment to a life of Obedience, Conversion, and Stability. Positioned over the central painting is a piece of found wood accented by gold leaf, in reference to the plaque nailed over Christ's head at the Crucifixion. Each painting could stand alone, just as we all do as individuals. Yet together, the three paintings are a more powerful depiction and symbol of the intentional and sacrificial offering of each vowed Community of Jesus member.

Journey is similar to *Yes* in that this particular tryptic endeavors to embody a Christian's daily walk through the utilization of texture and color on a polystyrene surface (See figure 3). Inspired by Paul's words from Romans 6:4, ". . . we too might walk in newness of life," if one observes closely one can see images of shoe prints and other mark making. These textures in combination with the simplicity of black and white acrylic paint, silver leaf, and burned surface evoke the footprints of struggle and joy experienced by all pilgrims in the way of the cross.

While I appreciate pure abstraction, I find my work holds a firmer content with recognizable elements as symbols. For this reason, I often employ shoes in my work. As a symbol, the shoe is utilitarian; everyone understands its purpose and can relate to this ordinary object. We all wear shoes, and mankind has worn them for centuries; they have a stylistic history. In this way, the shoe can connect us to the present and the past. In the four-

painting series *Messengers*, I employ abstracted forms of high-heeled shoes, which are intersected by color, texture, and form; all of the aforementioned rest on pages taken from a repurposed King James Version Bible. The abstraction undergirds the idea of movement and flight, for in my imagination I see angels wearing shoes. In this way the otherworldly becomes tangible. (See figure 5.)

Another example of symbol grounding the viewer in the present is the central work that I fabricated for the exhibition *Frammenti*. This sculptural piece hangs suspended from the ceiling over the massive floor cross fabricated by Italian artist Filippo Rossi. Composed of papier mâché, the blue, orange, and gold leafed sculptural pieces seem fractured, yet their fragmentation is held together by a pair of shoes and the cross. (See figure 6.)

One knows without really understanding all the parts, the fragmented sculpture is a figure; the shoes ground it in the familiar, the quotidian. In this way, the figure is seen in conversation with the cross below, suggesting a movement of immersion. The sacred mystery of baptism is explored utilizing two symbols, shoes and the cross, and also through the eyes of two different faith traditions. Filippo Rossi, who is Catholic, and I collaborated to create *Frammenti*. The fragments represent our different faith experiences, which come together in conversation; sacred art communicates a oneness of vision toward an ecumenical communion.

The image of the cross is also a strong presence in my work. The universal sign of all Christendom, the geometrical figure of all Christian faith traditions, the power of the cross in sacred art is undeniable. For the 2015 International Art Exhibit of Contemporary and Sacred Art, *Si Fece Carne*, held in the Basilica of San Lorenzo, Florence, Italy, I again chose to express narrative through symbol. Inspired by the Venantius Fortunatus hymn

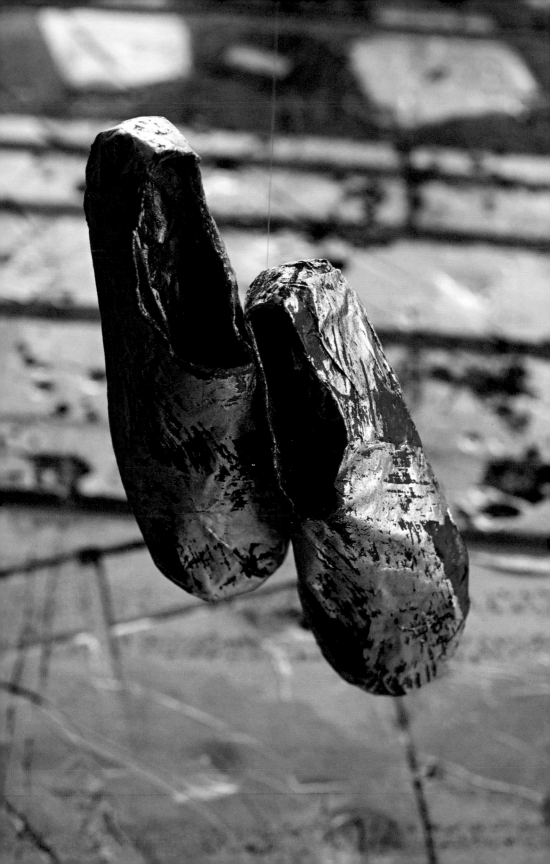

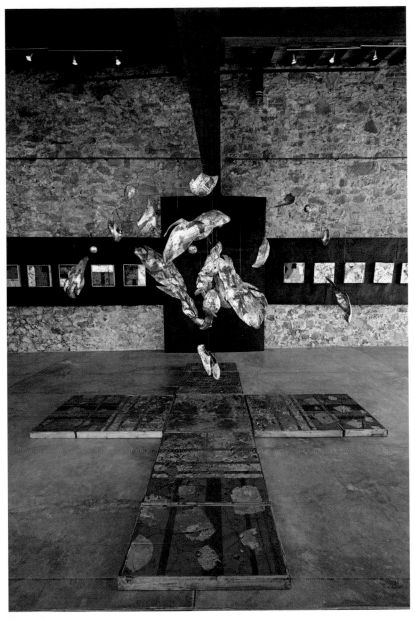

Figure 6

(Facing page) Figure 5: Central installation, *Frammenti* exhibition, 2015;
 Susan Kanaga, *Fragmented Figure*, detail
Figure 6: *Frammenti* exhibition, 2015; Susan Kanaga, suspended sculpture
 Fragmented Figure; Filippo Rossi, *Floor Cross*

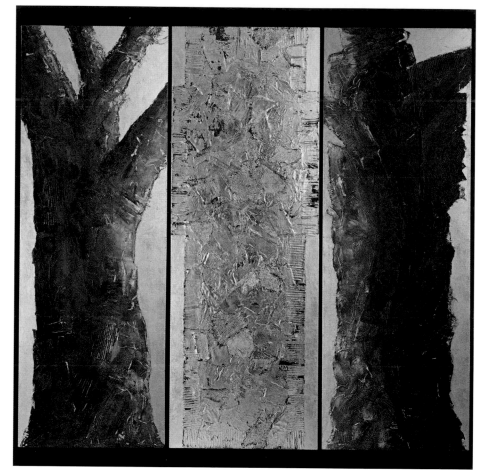

Figure 7

"Crux Fidelis" (sung on Good Friday in the Church of the Transfiguration and in dioceses in the USA), I chose to employ "the tree" as symbol.

The triptych *Tree of Mercy, Tree of Life* explores man's fall from grace in the Garden of Eden, Christ's ultimate sacrifice for mankind on a tree, and Crux Fidelis, "noble tree beyond compare." Each of the three panels glimpses one part of the salvation mystery, and together they speak of man's hope in God's promise of redemption. (See figure 7.)

Each panel is built using abstraction. The natural materials used to convey the essence of each tree such as burlap, paper, cardboard, cork, and wood are found in everyday life. They reference the lowliness of Christ's birth and infuse the timeless with the now. The use of gold leaf speaks of hope, redemption, and salvation— all intangible concepts—, and of the mercy of God who gave his only Son to suffer and die for his people. For surely the life of our Savior and Lord Jesus Christ, his sufferings, crucifixion, and death have led us all to a new life him. In him we are one, and for this he has given us a reason to hope.

Figure 7: Susan Kanaga, *Tree of Mercy, Tree of Life*

FOTIS KONTOGLOU AND THE STRUGGLE FOR AN "AUTHENTIC" ECCLESIASTICAL ART IN GREECE

Vasileios Marinis, Yale University

F otis Kontoglou (1895–1965) remains one of the most influential and controversial Greek artists of the twentieth century.[1] He was born in Ayvalik, in what was at the time the Ottoman Empire, and was educated at the School of the Arts in Athens. He also lived in Paris and traveled extensively, including in Spain, Belgium, and elsewhere. In 1922 Kontoglou moved permanently to Athens, where he worked as a painter, illustrator, and art restorer. He was also a voluminous writer, authoring several articles and books of fiction and nonfiction.

To understand Kontoglou we must discuss art production and education in Greece in the nineteenth and early twentieth centuries.[2] Greece became an independent state in 1830. During the following year, the Bavarian prince Otto von Wittelsbach (1815–1867) was installed as the monarch of the newly established kingdom. In the context of the reorganization and modernization of the nascent state, as well as in an effort to create a national identity, Otto's German consultants and the native intelligentsia espoused a narrative that emphasized the state's connections with the glorious age of classical antiquity and downplayed those of the Byzantine and post-Byzantine periods. Art, especially of the post-Byzantine era, was considered to be

"decadent" (or, even worse, "barbaric"), and in need of drastic amelioration. In general, the shortcomings of Byzantine art, such as its lack of perspective and anatomical inaccuracies, were to be corrected through the application of Western principles of painting.[3] The result was an ecclesiastical visual language that combined a variety of influences, including Neoclassicism, late Academicism, and, primarily, the Nazarene movement. Byzantine idioms, however, were not completely abandoned.

The Bavarian painter Ludwig Thiersch (1825–1909) is one of the most outstanding representatives of this style. Thiersch was educated in the Akademie der Bildenden Künste in Munich and was well versed in Academic art. During his residency in Greece between 1852 and 1855, when he taught at the School of the Arts, he also familiarized himself with Byzantine art, especially the eleventh-century mosaic ensembles of Daphni Monastery in Attica and Hosios Loukas in Boeotia. Thiersch was commissioned to decorate several churches, the most important of which was the Russian Church (also known as Soteira Lykodemou) in Athens.[4] These paintings are firmly Academic and Nazarene in style, but they contain reminiscences, however distant, of Byzantine mosaics, especially those in Daphni. Interestingly, Thiersch's selection of many of the saints (depicted either standing or in medallions) was evidently based on their connection to the Athenian Church. Despite his rather brief stay in Greece, Thiersch was very influential, both through his work and through his teaching. Nikephoros Lytras and Spyridon Chatzigiannopoulos, two of the most distinguished nineteenth-century Greek painters, were his students. They also assisted him in Soteira Lykodemou.

Figure 1: George Kordis, born 1956, *Presentation in the Temple*

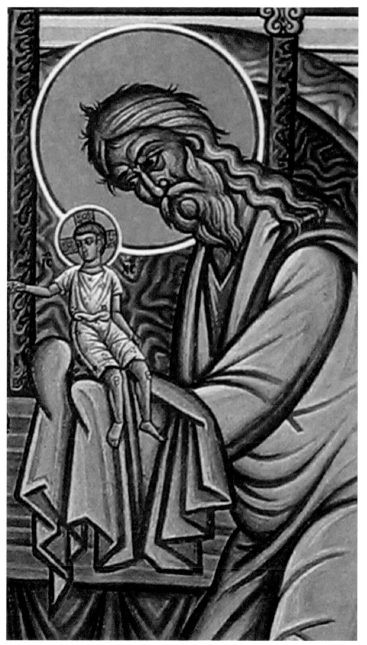

Figure 1

———•———

Although in his later texts he is largely dismissive of Western religious art, Kontoglou was, to be sure, an astute student of Renaissance and later Western painters.[5] Early in his career he was a great admirer of painters Domenikos Theotokopoulos (c. 1541–1614) and Vincent van Gogh (1853–1890). Furthermore, he could be critical of Byzantine art, whose compositions he sometimes found unbalanced.[6] But these opinions evolved. The reasons for this evolution were certainly manifold,[7] but one of the most consequential seems to have been his numerous visits to Mount Athos, the most important center of Byzantine monasticism, in the 1920s. There he came into extensive contact with Byzantine and post-Byzantine fresco ensembles and icons, which dramatically altered his philosophy of painting.[8] By 1930, Kontoglou had developed his trademark style and used it in both his secular and religious works. Concomitantly, he began a decades-long campaign to rid ecclesiastical painting in Greece of its Western influences.

What was it that Kontoglou disapproved of in Western religious art? And why did he believe that Byzantine art to be more appropriate for the church? These questions are not always easy to answer. Kontoglou addressed them in many of his writings but not always in a systematic way; furthermore, he was not entirely consistent. For the sake of brevity, I examine here only one of his essays, titled "The Byzantine painting and its true value."[9]

The first claim that Kontoglou makes in this essay is that Byzantine art cannot be understood by scholars who approach it only as a field of inquiry, neither by those who judge it aesthetically. It is only the practicing Orthodox, those who live with this art, who can truly understand it.[10] Byzantine art

is incomprehensible when approached through the lens of classical or Italian Renaissance art. Byzantine art does not move people in the way of these other styles. It lacks naturalism and perspective, correct anatomy, and the usual standards of beauty. Yet all these traits, to Kontoglou, are unnecessary. Simplicity is beneficial to both body and soul. Byzantine art transforms people from material into spiritual beings. With its mystical forms and colors it wants to express the divine love that devours the saints it paints.[11] Because Byzantine art is spiritual, it cannot be measured in physical means.[12] Byzantine art, argues Kontoglou, reflects the mystical riches of God's Kingdom.[13]

For Kontoglou the fundamental distinction of Byzantine art lies herein: Byzantine icons are spiritual, while the paintings of artists like Raphael are physical (i.e., worldly).[14] Even religious Renaissance art is, in reality, secular art, because it expresses the secular spirit of the Catholic Church (which had acquired secular power), especially when it was mixed with the rationalism of ancient philosophy. Thus, Italian Renaissance art is the rebirth of ancient, pagan, worldly art.[15] The Italian painters did not paint liturgical art; religion, writes Kontoglou, was just an excuse for them to paint "their conceited sentimentalities." Their work is not made of icons to be venerated but rather paintings.[16]

Kontoglou argues that with the revitalization of classical art, church art lost its spiritual, mystical character, and from liturgical became naturalistic. The individual came to replace tradition and artistic liberty was exalted. Kontoglou argues, however, that this liberty is an illusion. The master who works with his imagination and seeks, because of his vanity, to show off his mastery, is a slave to his baser passions. By contrast, the iconographer, with his adherence to tradition, is truly free. The iconographer working in the Byzantine tradition follows a given

Figure 2

form, but each interprets that form according to his piety. The religious art of the Renaissance lost its catholicity, by contrast, on the altar of individualism.[17] Furthermore, with the involvement of science,[18] art became complex, experimental, fake, and crowded with unnecessary additions.[19]

In Byzantine art, Kontoglou continues, rationalism is eradicated in favor of the wonderful and the apocalyptic. Its lack of perspective suspends time and allows the faithful to see everything.[20] It employs nothing of the abstract symbolism and theatricality of Western paintings. The figures in the icons could not be mistaken for actors in a play, nor icons for paintings of operas.[21]

It is easy to point to Kontoglou's biases. Yet, if we peel back the overgeneralizations and contention in "The Byzantine painting and its true value," many of his observations are quite correct. There are essential—one might say ontological—differences between a Renaissance religious painting and a Byzantine icon. Their divergent styles indicate contrasting systems of viewing, interpretation, and symbolism, and the way that each functions in a worship space is radically different. Kontoglou essentially argues that the way a Western painting looks and operates is incompatible with Orthodox spirituality, especially in the twentieth century.[22]

Notes:

1 Due to space limitations, in this essay I only give a basic bibliography. For Kontoglou see *Οἱ Ἕλληνες ζωγράφοι, vol. 2: Ὁ εἰκοστὸς αἰῶνας* (Athens: Melissa, 1976), 212–251; Nikos Zias, *Φώτης Κόντογλου, Ζωγράφος* (Athens: Emporike Trapeza, 1991).

Figure 2: George Kordis, *The Martyrdom of St. Loukia*

2 See Antonia Mertyri, *Η καλλιτεχνική εκπαίδευση των νέων στην Ελλάδα (1836-1945)* (Athens: EIE, 2000); Nikolaos Graikos, *Ακαδημαϊκές τάσεις της εκκλησιαστικής ζωγραφικής στην Ελλάδα κατά τον 19ο αιώνα. Πολιτισμικά και εικονογραφικά ζητήματα* (Thessalonike: n.p., 2011). For historical background see Thomas W. Gallant, *The Edinburgh History of the Greeks, 1768 to 1913* (Edinburgh: Edinburgh University Press, 2015).

3 Antonis Danos, "The Culmination of Aesthetic and Artistic Discourse in Nineteenth-century Greece: Periklis Yannopoulos and Nikolaos Gyzis," *Journal of Modern Greek Studies* 20:1 (2002): 75–112, esp. 75–86. See also Miltiadis Papanikolaou, *Γερμανοὶ ζωγράφοι στὴν Ἑλλάδα κατὰ τὸν 19° αἰώνα (1826-1843)* (Thessalonike: n.p. 1981).

4 Soteira Lykodemou was originally built in the first half of the eleventh century but has undergone considerable alterations and renovations. For the nineteenth-century iconographic program of this church, see Nikolaos Graikos, "Η «βελτιωμένη» βυζαντινή ζωγραφική στον 19° αιώνα. Η περίπτωση του Σπυρίδωνα Χατζηγιαννοπούλου," MA Thesis, University of Thessalonike, 2003, 193–221.

5 See, for example, Fotis Kontoglou, *Γιὰ νὰ πάρουμε μιὰ ἰδέα περὶ ζωγραφικῆς* (Athens: Armos, 2002).

6 *Οἱ Ἕλληνες ζωγράφοι, vol. 2,* 216.

7 See the extensive analysis in Ryan P. Preston, "The 'eternal return' of the Byzantine icon: Sacred and secular in the art of Photis Kontoglou," PhD Thesis, Harvard University, 2010, 54–180.

8 This was, in a sense, a paradox. At that time, the dominant style of icon painting in the Holy Mountain was largely inspired by Russian ecclesiastical painting, in a style very close to Academicism.

9 Fotis Kontoglou, "Ἡ βυζαντινὴ ζωγραφικὴ καὶ ἡ ἀληθινή της ἀξία," in *Ἡ πονεμένη ρωμιοσύνη* (Athens: Astir, 1963), 96–119 [hereafter "Βυζαντινὴ ζωγραφικὴ"]. Some of Kontoglou's essays on art have been translated in Constantine Cavarnos, trans., *Byzantine Sacred Art: Selected Writings of the Contemporary Greek Icon Painter Fotis Kontoglous on the Sacred Arts According to the Tradition of Eastern Orthodox Christianity,* 2nd ed. (Belmont, MA: Institute for Byzantine and Modern Greek Studies, 1985).

10 "Βυζαντινὴ ζωγραφικὴ," 96–97.

11 "Βυζαντινὴ ζωγραφικὴ," 101–102.

12 "Βυζαντινὴ ζωγραφικὴ," 102–103.

13 "Βυζαντινὴ ζωγραφικὴ," 104.

14 "Βυζαντινὴ ζωγραφικὴ," 104.

15 "Βυζαντινὴ ζωγραφικὴ," 105.

16 "Βυζαντινὴ ζωγραφικὴ," 106.

17 "Βυζαντινὴ ζωγραφικὴ," 110–112.

18 For the calculation, e.g., of perspective.

19 "Βυζαντινὴ ζωγραφικὴ," 111.

20 "Βυζαντινὴ ζωγραφικὴ," 116.

21 "Βυζαντινὴ ζωγραφικὴ," 118–119.

22 For the consequences of Kontoglou's campaign see Georgios Kordis, "The Return to Byzantine Painting Tradition: Fotis Kontoglou and the Aesthetical Problem of Twentieth-Century Orthodox Iconography," in *Devotional Cultures of European Christianity, 1790-1960*, ed. Henning Laugerud (Dublin: Four Courts Press, 2012), 122–130.

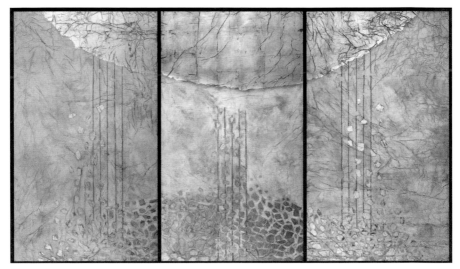

Figure 1

THE ARTIST AS CONTEMPLATIVE

Filippo Rossi

A work of "visual" art obliges us to look at what the artist has in fact visualized. If the artist has incorporated not only ecclesiastical and theological themes, but also spiritual and personal meaning, his work assumes a contemplative character; an artist who, as he paints, also prays, in fact contemplates. The sixteenth-century writer Giorgio Vasari says that Fra Angelico, the holy Dominican friar who was also a great artist, never painted a crucifix without shedding tears; his was thus not only a spiritual but also a deeply personal contemplation of his subject. This is a method that helps artists grow—one that increases their creativity, assists their artistic mission.

As a Roman Catholic, I believe that no one better than Mary can teach us this method—she who is expert in prayer, she whose prayer became flesh, she who contemplated God within herself. She was able to listen and to say "Yes" to Almighty God, magnifying him in her soul for the great things he did in her life. I wish to begin, therefore, by speaking of my painting "Magnificat," which is part of the Community of Jesus's collection and hangs in the corridor leading to the church. (See figure 1.) This triptych expresses the threefold unity of a movement which is also stillness, just like the biblical event it evokes, involving Mary, the angel,

Figure 1: Filippo Rossi, born 1970, *Magnificat* triptych

Figure 2

and the Holy Spirit, and just like every echo of the Incarnation in our own lives. The disk in the upper part of the triptych is a material visualization of the God who is love, radiant and intense but also unchanging, still. The "mother" in this story, in the last analysis, is really God's project, to "become like us to make us like him," as saint Augustine says. But what can art perceive of this mystery? How can art become its voice and sign?

For me it is a question of a felt inner vibration which can be translated in musical terms: everything becomes sacramental cosmic harmony. That is why I designed three musical staves on which notes ascend and descend like golden petals. These are God's seeds, rich in fruit. Here where the subject is the Father and the Son, we also have Mary, fecundated by grace, and so the theme also includes a mother and daughter, in a purity that is absolute because it complements God's own purity. She is the humble servant toward whom the Lord has turned his gaze, whom he has touched with his Spirit, whom he has lifted up, casting down the mighty from their thrones. If we break the account of the *Magnificat* into various moments, my painting would be the moment when Mary raises her song of praise to God. It is also the moment when God's power to save those who fear him reveals his mercy.

Holy! Holy! Holy! My *Magnificat* asks viewers to acknowledge that the Almighty's name is three times holy, and his greatness overflows in all creation. As "Sun of Justice" the Lord pours his mercy upon the earth, so that time dilates to become eternity and space expands, becoming infinity. In golden anticipation of unending glory, holiness and art announce the final summing up of all things in Christ. The artistic movement of the *Magnificat* stresses the dialogue among the three panels, all moved by a

Figure 2: Filippo Rossi, *Magnificat* triptych, detail

musical synchrony that can practically be heard—a symbolism that sings! For the *Magnificat* is not mere song, but rather the "Amen" to God's infinite silence that in Mary becomes a Word. It is God's dream becoming flesh. For God truly speaks, calling each of us in different moments and ways, planting the treasure of his response in us—the response which, when we utter it, perfectly realizes us. (See figure 2.)

All artists know these things, all artists have received this treasure and know—as Saint Paul did—that they have it in fragile, earthenware jars, so that it be clear that the extraordinary power is really God's and not our own, as the Second Letter to the Corinthians says (4:7). Another verse from the same letter defines the spirit that should guide all who, as artists or scholars, try to communicate God through art: "Animated by the same spirit of faith of which Scripture says: 'I believed and therefore I spoke out,' we too believe and therefore speak out, sure that he who raised the Lord Jesus will raise us too with Jesus . . ." (2 Corinthians 4:13–14).

I faced this "confessional" dimension of my own vocation in 2012, when the Franciscan Order asked me to do an exhibit on the theme of the cross at Assisi, at the Museum attached to the Basilica of the Porziuncula, where Saint Francis died in 1226. The reader will easily understand both my joy and my concern at the idea of exhibiting in such an important place! On the one hand, I had to produce works that were neither superficial nor obvious but convincing from an artistic point of view—works that would speak to the heart of Saint Francis's followers, there in one of the Order's sacred places. On the other I was personally responsible for the message of my works: I could not simply reproduce traditional Franciscan

Figure 3: Filippo Rossi, *Re-Velation*

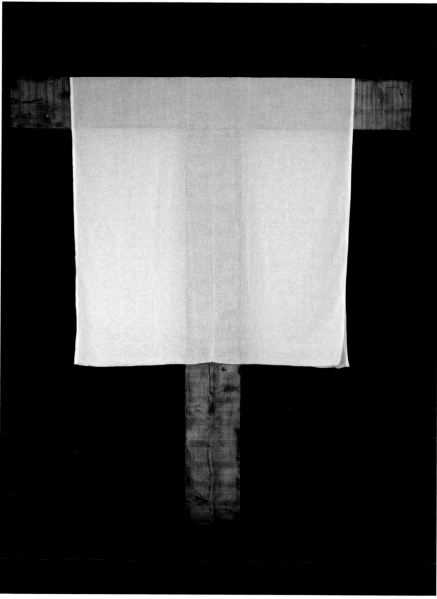

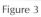

art. Above all I had to struggle to let my personal relationship with the subject of Christ's cross come through.

One of my works for that exhibition, *Re-Velation*, a Tau-cross almost six feet tall, was covered with a semitransparent veil that barely lets you see the cross behind it. (See figure 3.) I think the message is quite clear: the Cross—that is to say, Death—has been defeated in Christ's resurrection, suggested by the veil, which is the abandoned shroud. It is extremely difficult to create a work like this without praying. Often I have to struggle to keep calm during the creative process, until I myself see clearly what I want to communicate. The Assisi exhibition was later transferred almost entirely to Santa Croce, the huge Franciscan church in Florence famous for its frescoes by Giotto.

Another work from the Assisi show was *At the Heart of Glory*, which represents a completely gilded cross within which we see a perforation, a very dark part realized with fire, which stands for the center of Christ's glory, his giving all himself, his despoiling of himself, so that we might have the gift of eternal life. (See figure 4.)

I also did a work entitled *The Price*, a variation of the theme just illustrated. (See figure 5.) The "price" is what the Lord paid for all of us, completely emptying himself of himself. His glory, suggested by the gold leaf, completely clothes humankind while Jesus remains there on the cross, "with neither attraction nor beauty for our eyes, like one before whom we shield our eyes," as Isaiah says (Isaiah 53:2ff).

Figure 4: Filippo Rossi, *At the Heart of Glory*

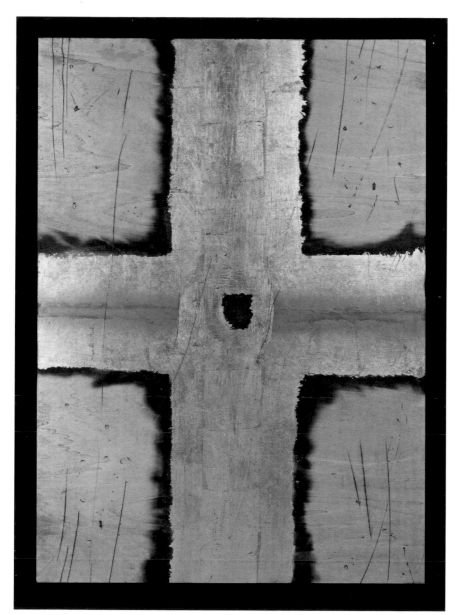

Figure 4

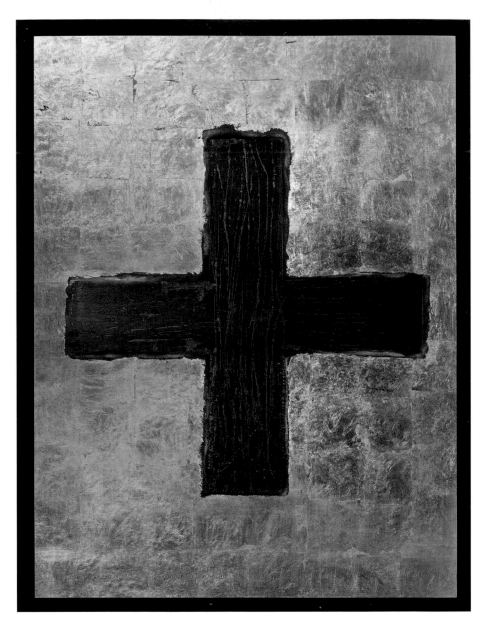

Figure 5

These themes are close to those treated by Pope Benedict XVI when he met with artists in the Sistine Chapel in 2009, a gathering to which I had the very great honor to be invited. The Pope said that "Beauty—from that which we see in nature to that which is expressed in works of art—, precisely because it broadens the horizon of human consciousness, because it pushes it beyond itself, because it brings consciousness to the abyss of infinity, can become a way leading to Transcendence, to the final Mystery, to God." "Art," he said, "in all its expressions, whenever it faces the great questions of existence, with the fundamental themes from which the meaning of life derives, can assume religious meaning and transform itself in an itinerary of deep inner meditation and of spirituality." From this, I believe, we can conclude that art is like prayer! Benedict XVI, like Paul VI before him, saw artists as collaborators in his high priesthood, not only because they are masters of signs but also because they are also "apostles" of hope and "mediators"—in the logic of the Incarnation—between the world of matter and that of the spirit. "Through your art," Benedict told us, "be announcers and witnesses of hope for humanity!" He assured us that "faith takes nothing away from your genius, from your art—on the contrary, faith enhances and nourishes talent and art, encouraging them to cross the threshold and to contemplate, with eyes filled with fascination and emotion, the Sun without sunset that illuminates the present and makes it beautiful."

Pope Benedict concluded with words of Saint Augustine describing the beatific vision—the direct vision of God in heaven to which we are all called. "My brothers, we will enjoy a vision never previously contemplated by human eyes, never heard by

Figure 5: Filippo Rossi, *The Price*
(Pages 58–59) Figure 6: Filippo Rossi, *Gemmed Cross*

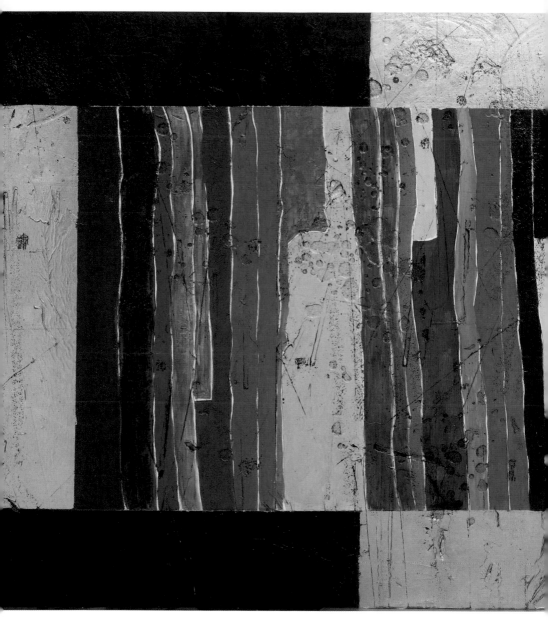

Figure 6

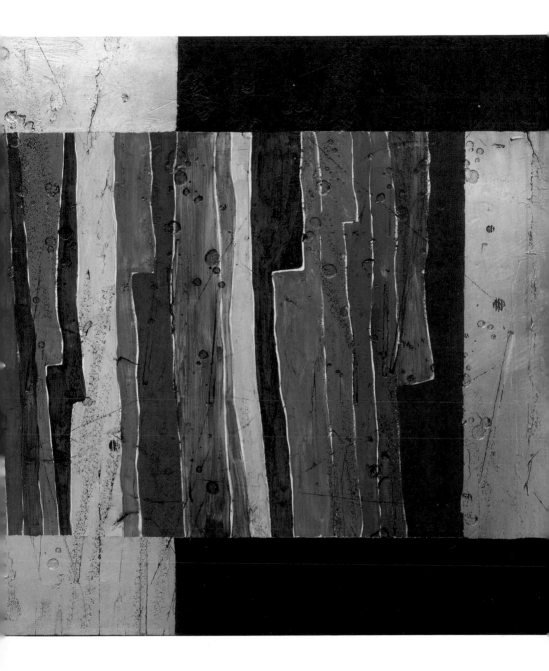

human ears, never imagined by human fantasy: a vision that surpasses every earthly beauty, that of gold, that of silver, that of the woods and fields, that of the sea and the sky, of the sun and of the moon, of the stars and of the angels. And the reason is this: the Beauty we shall behold is the source of every other beauty!" (In Ep. Jo. Tr. 4,5: PL 35, 2008.) In this spirit, a work of mine represents Christ's sacramental body contemplated in adoration—a full plunge into direct prayer!

━━━·■·━━━

In addition to being a practicing artist, I also have a university degree in the history of art, and have for decades been an observer of Christian art seen not only in the perspective of its changing styles but also as a knowledgeable and loving synthesis of the faith of the Church which, across the centuries, has been transmitted from one generation to the next. In my studio in Florence, full of canvases, acrylic paint tubes, brushes of all kinds, notes and sketches, there is also a bookcase crowded with volumes with the most varied titles, for I believe that Christian art also expresses love of learning and the untiring search for the Truth which is Christ. I believe that my own work, despite its contemporary language, breathes the air of church tradition.

An example is a large, multicolored cross I painted to give new life to the great gem-studded crosses of the fifth and sixth centuries, so rich in precious stones and pearls: expressions of faith and objects of devotion in the majestic apse areas of churches such as Santa Pudenziana, in Rome, or Sant'Apollinare in Classe,

Figure 7: Filippo Rossi, *Column of Faith*

Figure 7

Figure 8

in Ravenna, or set on altars, as was the splendid cross donated by a Byzantine Emperor to the Pope in the sixth century, and still visible in the treasury of Saint Peter's. (See figure 6.) It is the kind of magnificent object that the Community of Jesus has evoked in the processional cross used in the Church of the Transfiguration.

In my case, the gemmed cross, made for an exhibit at the thousand-year-old monastery of Camaldoli, in Tuscany, was at the center of other pictures, all brilliant in their colors: red, orange, yellow, blue, indigo violet, white, and black. All these works were born together, as a unitary project, almost an emanation of the big cross, as if generated by it. Each painting contains the wonder of a new and unrepeatable life where every sign or scratch, surface undulation or variation of tone, groove, or coagulation of pigment, refers to the complexity that every human experience has in itself. These nine pictures evoking the multiple experiences of human life are all "traversed" (and thus unified) by luminous blades of gold, as light as if moved by a gentle breeze, fire of Pentecost, presence of the Holy Spirit.

And opening—or perhaps closing—the Camaldoli exhibit was an imposing ten-foot-high column made with many sections of a pine trunk: the column of fire that guided the people of Israel in the desert (Exodus 13:21), Christ who on the cross defeats the shadows of sin. (See figure 7.)

Each of the sections, distinguished from the others by a different color, has, inscribed in a different language, the phrase: "I believe in God," which lessens the distance between peoples and cultures, destined to be overcome one day through shared love of the Father, Son and Holy Spirit. And each of these rings turns on its own axis,

Figure 8: Filippo Rossi, *Column of Faith*, detail

a simple gesture that alludes to the passage of time or to a child's carefree game, but also to great "circular" prayer traditions like the rosary or the Buddhist prayer wheel. (See figure 8.) The show opened and closed, that is, with a gesture—a humble and silent sign, full of expectation and gratitude, that precedes words in the grace-filled contemplation of the unfathomable mystery of God.

BEAUTY IN AND OF THE CHURCH: THE CHURCH OF THE TRANSFIGURATION

Martin Shannon

*One must always, by looking at what he can see,
rekindle his desire to see more.*[1]
Gregory of Nyssa

The Cappadocian Father Gregory of Nyssa (c. 330–395) saw in the life of Moses a symbol of the soul's journey to God, and he dedicated an entire volume to exploring that image in all of its various dimensions. Among them was the great Lawgiver's ascent on Mount Sinai and the days of mysterious "darkness" that he spent there alone with God. Moses's encounter with God, whom he never "saw" face to face, nevertheless left his own face shining with brightness. What he did see, says Gregory, awakened within him a longing to "see" more, a longing that he expressed when he said, "Show me your glory, I pray" (Exodus 33:19, NRSV). "Such an experience," Gregory reflects, "seems to me to belong to the soul which loves what is beautiful. Hope always draws the soul from the beauty which is seen to what is beyond, always kindles the desire for the hidden through what is constantly perceived."[2] Beauty that is perceived by the senses, while pleasing, is not satisfying. It draws, it compels, it awakens, and it points beyond itself. Beauty leaves its witness with an appetite for more.[3]

In his succinct review of Protestantism's cautious, one might say even inconsistent, relationship with aesthetics over the last five hundred years, William Dyrness argues persuasively that, having embraced beauty in other arenas, now may be the time for Protestants "to open their worship spaces to visual beauty as a sign of God's presence." It is possible that beauty has its rightful place in the very place where beauty's Giver is sought and praised. Certainly, the Reformation's quincentennial at least raises the question. So also do the advances in ecumenism that have taken place in the most recent generations, especially since the Second Vatican Council.

From her own doctoral research on the relationship between theology and the visual arts, Gesa Elsbeth Thiessen of Trinity College, Dublin, (who also teaches both ecumenism and modern Irish painting) has compiled a collection of writings on theological aesthetics from Justin Martyr to Jürgen Moltmann, from Martin Luther to Hans Urs von Balthasar. Introducing this symphony of voices, she observes:

> In the last century ecumenical theology and the quest for the unity of the churches made great advances. In this context it is interesting to note, that theological aesthetics has occupied scholars from all major denominations. While Roman Catholics, Lutherans, and Anglicans have been foremost in the dialogue between theology and the arts, now scholars of the Reformed tradition increasingly engage with questions including the role of the visual image in places of worship, distancing themselves from some of the Calvinist iconoclast polemics of the past. This field of theology is per se ecumenical, i.e. without having consciously set out to achieve such aims. One would suggest that this can only be of benefit to theology,

ecumenical relations and the wider search for Christian unity.[4]

Some have made the case that the ecumenical project has slowed dramatically since the fervor of the mid- to late twentieth century.[5] Thiessen is not alone in suggesting, however, that one arena in which it continues to move forward, (even if with glacial velocity), is in the attention being given to theology and aesthetics.[6] If it is also true—and many have argued that it is—that the cause of church unity is also taking place effectively in the world of monasticism,[7] then the Church of the Transfiguration at the Community of Jesus on Cape Cod, Massachusetts, is one place where those two worlds have come together.

AN ECUMENICAL MONASTERY

Because the origins of the monastic charism predate the major separations that have since divided the church, it is a particularly eloquent expression of the call to unity in the Body of Christ, and the monastery itself is especially suited to promoting peace and understanding among God's people. We are committed to furthering the ecumenical vision that has inspired so many before us, and we pray for and work toward reconciliation in the whole Body of Christ. (*Rule of Life of the Community of Jesus*, Chapter 5: "The Call to Reconciliation and Unity")

The Church of the Transfiguration was dedicated in 2000, after more than nine years of planning and well into the fourth decade since the Community's founding. Its architectural design, the art that adorns it, and the liturgical life that it houses are all,

in part, expressions of the Community of Jesus's commitment to ecumenism and its vision for full and visible unity in Christ's church. The Community's own origins are rooted in the time of ecumenical advancement surrounding the Second Vatican Council (1962–1965), the pan-denominational charismatic movement, and other efforts toward reconciliation and church unity. That period saw the birth of dozens if not hundreds of intentional Christian communities, born of the conviction that a life of commonly shared prayer and work and ministry was a biblically mandated way to grow as faithful disciples of Christ and to witness to the world. The earliest members of the Community of Jesus came from various, even divergent, church backgrounds. They endeavored to overcome their differences (both personal and theological) through a fervent commitment to the truths that they held in common and by their mutual pursuit of holiness and love. The Community's *Rule of Life* goes on to say:

> As members of an ecumenical community, we are grateful for the truths we have been given and the examples of faith we have been shown in the traditions from which we have come. It is part of the grace given to us that we can look to the values of our many traditions for enrichment to the life and worship of this community. Drawing upon our varied backgrounds, we seek to build upon what is most commonly treasured by us all, in order to realize a unity that is greater than the differences that have historically divided church bodies and denominations. (*Rule of Life*, Chapter 5)

Figure 1: Early basilica architecture, the Church of the Transfiguration, Orleans, Massachusetts

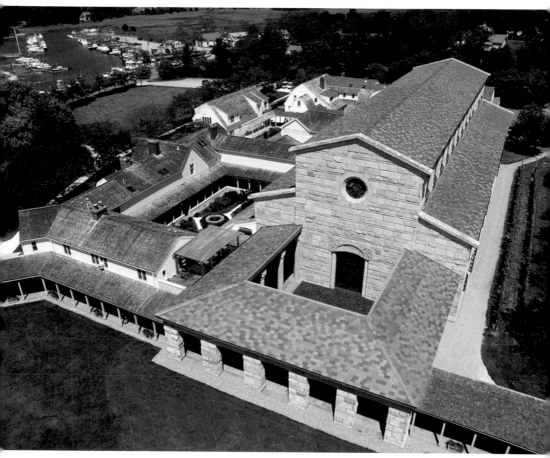

Figure 1

Paul Couturier (1881–1953) was an early promoter of the Week of Prayer for Christian Unity who saw the unity of the church as the fruit of converted lives. He called Christians at prayer for unity an "invisible monastery," where constant prayers for reconciliation are made, where mutual love is shared, and where conversion of heart and holiness of life are pursued.[8] The Community's pursuit of this kind of "spiritual ecumenism" gives one visible shape to the values inherent to monastic life. The Church of the Transfiguration was built with these principles clearly in mind, especially as it drew upon early designs and concepts that are now shared in common by all branches of the church (e.g., early basilica architecture, figure 1).

Remaining faithful to the ecumenical identity of the Community, and giving visible expression to that identity, were among the prime aims that governed the planning process. So also was the conviction that artistic creativity belongs to the realm of prayer. The Community's commitment to the place of beauty and the work of art in its life is articulated in the *Rule of Life* under the heading "Living to the Glory of God" in a chapter entitled "The Call to Live for God." Members of the Community believe that those made in the image of their Creator in turn learn to create, every much as they learn to serve, to sacrifice, and to love. If, as we firmly believed, the building we built would "build" us in return—teaching, shaping, directing, and transforming our lives—then great care as well as vision would be required in its creation. These values led to the intentional choice that the church would house visual beauty, as well as beauty in language and in music, as "privileged carriers of authentic spirituality" (Dyrness). Community members believed then, and still do, that, by presenting itself to the human soul in all of its multiple facets, visual beauty, as an incarnated "image" of the Word of God, would kindle within us a desire to "see more."

TEACHING THE GOSPEL

At one level the Church of the Transfiguration informs and instructs, through its design and structure, through the materials with which it is built, and through the iconography that it contains. In the limited language of architecture and art, the church teaches what it can about a limitless God. Through its stone carved liturgical furnishings, frescoes, mosaics, and sculptures, it portrays the history of salvation as recorded in the Bible, from the Book of Genesis in the atrium to the Book of Revelation in the apse. From ceiling to floor, west to east, outside to inside, the church teaches the message of God's saving plan in Jesus Christ, telling its foundational stories and presenting its fundamental truths.

The primary emphasis placed upon the proclamation of God's word and the sacraments is read unmistakably in the central fixed locations of the baptismal font, the ambo, and the altar. Even in the profound silence of their presence, these liturgical furnishings speak eloquently and insistently about what is most important in the church's life of prayer. As the sign of rebirth by water and the spirit, the font presents itself immediately to all who enter the door. The ambo stands in the midst of the church, in direct line between the font and the altar, as if pointing to each while connecting them as well. Finally, for the celebration of the Eucharist, what the Community's *Rule of Life* describes as "the church's supreme act of thanksgiving" (Chapter 3), the altar is set as the apex of the church's linear design.

The arrangement of processing saints that appear between every image of Christ in the clerestory frescoes represents the pilgrimage of the redeemed coming from every nation, tribe, and tongue (Isaiah 60) to set their lives and their gifts before the throne of the Lamb. (See figure 2.)

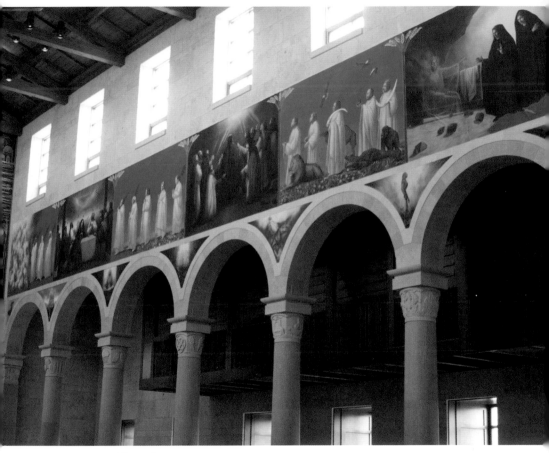

Figure 2

With all of their differences they have this in common: the divinizing light of heaven shines upon them, reflecting from their white robes and glistening from their faces. The one communion of Christ's church, though as yet not fully known on earth, is made manifest in the kingdom of God. Jesus's prayer, that they all may be one, is answered there already.

With the saints above as witnesses, those below make their way as those who have been called by Christ to "come, follow me." The mosaic pathway running down the center of the church tells of the way of the cross—the true tree of life—that the church on earth is called to follow. (See figure 3.)

The steps of conversion, represented in a series of mosaic medallions set within the tree, are taken again and again by all disciples as they make their way to the re-opened gate of paradise (seen at the peak of the arch) and the welcoming arms of their Redeemer (the apse mosaic of Christ in glory).

SHAPING THE FAITH

At another level, like all beauty, the art of the Church of the Transfiguration does more than impart information. It forms and shapes the affections and the faith of those who pray within its walls. Over time and after repeated use, a kind of living relationship develops between the building and its inhabitants. More than inanimate objects to house religious activity, churches are active participants in the life of worship that goes on within them. They do more than teach, they beckon. (See figure 4.)

A dialogue develops between the church and the liturgy that it was built to house. Each does something to shape the other and, most of all, to shape the faith community that is common

Figure 2: The pilgrimage of the redeemed, the Church of the Transfiguration

to both. Like all liturgy, the church re-orients us by opening our vision and directing our hearts, again and again, to what life is all about, its true priorities, its true demands, and its true promises. Liturgical art and architecture change our perspective and nourish our faith.

ENCOUNTERING GOD

The reason it can be said that a church shapes faith is that, at a deeper level, once it has the viewer's attention, it points beyond itself to meanings and realities that lie "behind" its walls. This, said Paul Tillich, is what "beautiful" art means—"the power of mediating a special realm of meaning" by transforming reality.[10] Using sacramental terms, the church is a reference point for eternity, a visible door to an invisible world. It is a physical compass designed to point the way to Christ. More than a place for people to meet, the church is the scene for an encounter to take place with the living God, and facilitating this encounter is its highest purpose. In his autobiography, *The Seven Storey Mountain*, the Trappist monk Thomas Merton wrote of his experience as a young man walking into the artistically adorned churches of Rome. He said that these churches and their artwork spoke to him, even confronted him. He wrote that there, inside those buildings, he first met the Christ whom he would eventually come to serve for the rest of his life. This is because church walls are more than surfaces for art. They are the locus of a religious experience, something meant not only to be observed but to be entered into.

As central as it is to the church itself, for example, the altar is still meant to point beyond itself to Christ, the true altar of God

(Facing page) Figure 3: Mosaic pathway showing the tree of life, the Church of the Transfiguration

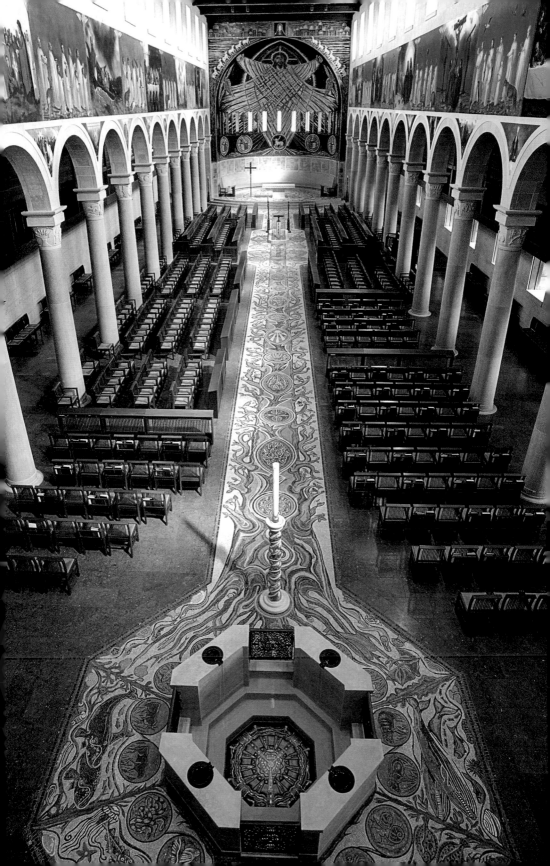

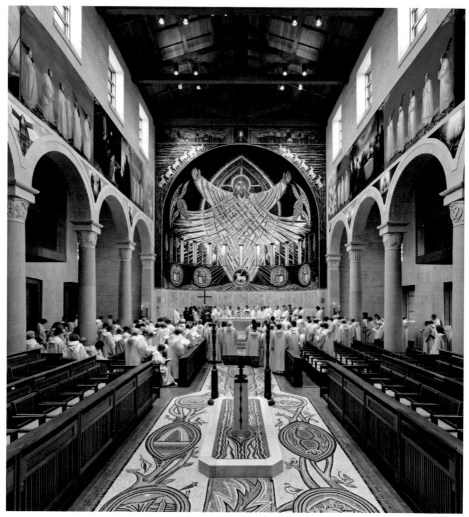

Figure 4

(see Hebrews 13:10f). We can say that we "see Christ" in the apse mosaic, not because he has limited himself to the colors and shapes of uniquely arranged pieces of glass, but because all that goes into that arrangement, including the creative imagination that it manifests, directs our attention beyond itself to the invisible Christ in Glory. We encounter God in a building made with human hands, not because God dwells in houses of hewn wood (Acts 7:48) but because he who once chose human flesh to be his tabernacle can still show his face through whatever form he chooses, including stone and mortar, plaster and pigment, bronze and gold. Poetically commenting on the magnificent doors of the new church of Saint-Denis in Paris, Suger, the great medieval abbot and patron of Gothic architecture, wrote:

> Admire not the precious or costly materials of these doors,
> but rather the craftsmanship of the work. It is brilliant
> and noble.
> All noble work, through its beauty,
> illumines souls to the genuine splendors,
> lifting them to the true light, of which Christ is the door.
> This gilded door merely prepares you for what shines
> beyond it.[11]

Behind these doors, "behind" every church, lies the Mystery each signifies. This is what attracts us to pay attention as well as what protects us from idolatry. While it may teach us the Gospel, and even shape our lives in the ways of faith, the church still remains a servant. It stands as an interactive sign pointing to the true house of heaven, even as it makes way for all who enter to experience a fresh encounter with the living God.

Figure 4: Churches, such as the Church of the Transfiguration, are active participants in the life of worship that goes on within them.

TRANSFORMING LIVES

Finally, visual beauty has its rightful place in the Church of the Transfiguration because, like all churches, this house of prayer is also meant to be a house of transformation. The section in its *Rule of Life* that discusses the place of art in the Community's life ("Living to the Glory of God"), is introduced with these words:

> As persons who have been consecrated to God and his service, we believe that every aspect of our lives is to be brought into harmony with God's purposes, so that in all things God may be glorified. In this way, both our labors and our lives come more and more to reflect the image of our Creator as we become co-workers with God in his ongoing creative activity. (Chapter 2)

"Living to the glory of God" is a description for "becoming," because ultimately it is lives that are meant to be beautiful.[12] For centuries, Christians have striven to understand (and fought one another over) what "happens" to the bread and wine in the celebration of the Eucharist. Of equal significance, however, is the question of what happens to *us*. Are *we* transformed in any way by participating in this holy mystery? Does something happen to *us*? In St. Augustine's terms, do we more "*become what we receive*"?[13]

Like the liturgy, the church is the locus for our own change, meant to assist in the re-formation of our lives into clearer reflections of our Creator and Redeemer. Going in and out of this space is meant to make one different, and some of the art speaks directly to this aspiration. The west wall, for example, presents an essentially abstract depiction of the Transfiguration. (See figure 5.)

While the oculus window above gleams fiery red, yellow, and white, the carved lintel below shows Peter, James, and John cowering in fear at the radiant vision. Filling the center part of the wall is a large glass panel of shimmering gold, which connects the two disparate images and reaches all the way to the floor. Those who walk through these doors share in some mysterious way in the epiphany that is depicted above them. We are reminded, as the *Rule of Life* states, that "our transformed lives can become bearers of the divine light" (Chapter 3).

In conclusion, two additional voices should be heard from the last century, both of whom were calling for renewed attention to be given to the role of beauty in the church. One was a Roman Catholic, the other a Protestant Evangelical. A generation and a continent apart, not to mention growing from two entirely separate branches of the church, each man delivered to his own world a similarly prophetic call for beauty's rightful place in the Christian life. Churches like the Church of the Transfiguration may owe some of their beauty to the contribution of seers like these.

Ildefons Herwegen (1874–1946) was a German Benedictine monk and the abbot of Maria Laach Abbey during that period when the monastery inspired and was home to some of the early promoters of the liturgical renewal. His own commitment to that renewal was reflected in a monograph entitled *The Art-Principle of the Liturgy*, in which he argued that the liturgy itself is a work of artistic beauty and, as such, it has the power to transform. "The purpose of the liturgy," wrote Herwegen, "is the transfiguration of human souls. It is this transcendent purpose that has brought out the inherent beauty of the liturgy and made it a consummate work of art. In a word: the idea of Christian transfiguration is the art-principle of the liturgy."[14] What implications does this have for the place of visual beauty in the very place that houses such liturgy?

Figure 5

Clyde Kilby's (1902–1986) career as an author and professor of English at Wheaton College in Illinois was coming into full swing about the time of Herwegen's death. While perhaps best known for his scholarship on the "Inklings" (Oxford's literary discussion group of the 1930s and 40s, including C. S. Lewis, whom Kilby knew personally, and J. R. R. Tolkien) and from that his founding of the Marion E. Wade Center, Kilby also lectured and wrote extensively on aesthetics. He approached the subject from a variety of angles—literary, musical, and visual—consistently arguing that Protestant Evangelicals must reconsider the place of aesthetics in the church. "We think," he said, "that a theory of aesthetics which begins with God is likely to be more fruitful than one that begins anywhere else." Because Christians are so "intimately related . . . to the Great Artist," they have "every right to feel at home in the presence of beauty." That beauty, said Kilby, certainly presents itself in nature. But it can just as well present itself in the creation of human hands. It was far more than a play on words when Kilby mused, "I have often wondered if there is any connection between the grace of Christ and gracefulness in art."[15] Kilby himself was convinced that beauty, in all its forms, needed to be embraced by Evangelical Protestants, not least of all because it is grounded *in* God and thus directs us *to* God.

These are among the reasons that the Church of the Transfiguration—a church for an ecumenical community of evangelical Benedictines—is *built* with art as well as with wood and stone. If beauty that is seen in the liturgy of the church draws the soul to the Beauty that is beyond, then I am inclined to think that Gregory of Nyssa would have heard in both Herwegen and in Kilby, distant echoes of his own voice.

Figure 5: The west wall, the Church of the Transfiguration

Notes:

1 Gregory of Nyssa, *The Life of Moses*, translated by Abraham J. Malherbe and Everett Ferguson (New York: Paulist Press, 1978) 116.

2 Ibid., 114.

3 "If beauty is 'a promise of happiness' (Stendahl), every gesture, every word and every action inspired by beauty is a prophecy of the redeemed world, of the new heavens and new earth, of all humanity reunited in the heavenly Jerusalem in endless communion. Beauty becomes a prophecy of salvation." Enzo Bianchi, "Holiness and Beauty," in *Words of Spirituality* (London: SPCK, 2002) 3–5.

4 Gesa Elsbeth Thiessen, *Theological Aesthetics: A Reader* (Grand Rapids, MI: Eerdmans, 2004) 3.

5 See William G. Rusch, "A Lutheran View of Where the Ecumenical Movement Stands in Spring of 2010," *Ecumenical Trends* 39:9 (October 2010) 129–133, and Walter Kasper, "May They All Be One? But How? A Vision of Christian Unity for the Next Generation," *Ecumenical Trends* 40:4 (April 2011) 49–54.

6 See for example Richard Viladesau, *Theology and the Arts: Encountering God through Music, Art, and Rhetoric* (New York: Paulist Press, 2000); Jeremy Begbie, ed., *Beholding the Glory: Incarnation Through the Arts* (Grand Rapids, MI: Baker Books, 2000); Janet R. Walton, *Art and Worship: A Vital Connection* (Collegeville, MN: Liturgical Press, 1991); Robin Jensen, *The Substance of Things Seen: Art, Faith, and the Christian Community* (Grand Rapids, MI: Eerdmans), 2004.

7 I have argued this myself in "Monasticism 'New' and 'Old' and the Cause of Christian Unity," *American Benedictine Review* 65:1 (March 2014) 3–24.

8 Paul Couturier, "Prayer and Christian Unity," *One in Christ* 2 (1966) 221–46.

9 Thomas Mathews has discussed this idea, particularly as it is seen in the "wedded" union of image and architecture in early Byzantine churches, making them "environmental work[s] of art." The church building, he writes, "beyond being a container for iconography, is a container for a religious experience." See "A Temple of Transformation," in *Byzantium: From Antiquity to the Renaissance* (New York: Harry N. Abrams, Inc., 1998) 98–135. For a more general discussion of see Nelson Goodman, "How Buildings Mean," in Nelson Goodman and Catherine Elgin, eds., *Reconception in Philosophy and Other Arts and Sciences* (Cambridge, MA: Hackett, 1988) 368–75. Goodman concludes: "A building, more than most works, alters our environments physically; but moreover, as a work of art it may through various avenues of meaning, inform and reorganize our entire experience. Like other works

of art—and like scientific theories, too—it can give new insight, advance understanding, participate in our continual remaking of a world."

10 Paul Tillich's first lecture to the Minneapolis Institute of Art in 1952, "Human Nature and Art," in John Dillenberger and Jane Dillenberger, eds., *Paul Tillich on Art and Architecture* (New York: Crossroad, 1989), 20.

11 In Anselme Dimier, OCSO, *Stones Laid Before the Lord: Architecture and Monastic Life*, trans. Gilchrist Lavigne, OCSO (Kalamazoo, MI: Cistercian Publications, 1999), 173.

12 Speaking to the general assembly of the Union of Superiors General (for male religious) and the International Union of Superiors General (for female religious), Pope Benedict XVI said: "The profound renewal of consecrated life stems from the centrality of the Word of God and, in more concrete terms, from the Gospel the supreme rule for you all. The Gospel, put into practice every day, is the element that makes consecrated life intriguing and *beautiful*, presenting you before the world as a reliable alternative. This is what contemporary society needs, this is what the Church expects of you: to be a living Gospel."

13 Augustine, Sermon 272 in Daniel J. Sheerin, *The Eucharist (Message of the Fathers of the Church)* (Wilmington, DE: Michael Glazier, Inc., 1986), 94.

14 Ildefons Herwegen, *The Art-Principle of the Liturgy*, trans. William Busch (Collegeville, MN: Liturgical Press, 1931).

15 Clyde S. Kilby, *The Arts and the Christian Imagination: Essays on Art, Literature, and Aesthetics* (Brewster, MA: Paraclete Press, 2017), 32.

ART AND THE LITURGY*

Timothy Verdon

I n practically all ancient cultures, monumental art is *religious* in character and specifically *connected with religious worship*. It is produced, that is, in the service of the liturgy, as a kind of "visualization of the mystery."

The liturgy—the complex of rites through which a given civilization manifests its relationship with God—is, moreover, itself *art* and a *generator of art*. Comprised of ritual actions combined with words, liturgy requires spaces in which to perform the actions and images to illustrate the words. Temples and processions, sacred music, paintings, statues, and vessels in turn imply the collaboration of professionals in these several fields—of architects and choreographers, composers and musicians, singers, poets, painters, sculptors, goldsmiths, and others still.[1]

In certain cultures, creative talent in the service of the liturgy was held to be a gift of God, and art in all its forms—every capacity to ideate and create beautiful things—was conceived in relation to the sacred. In Old Testament Israel, for example, the very origin of the arts was unequivocally presented as having a function connected with religious worship, and "the artists whom the Lord had blessed with wisdom and intelligence so that they might execute the works required for the construction of the sanctuary" were guided by Moses himself to make "everything just as the Lord had commanded," Exodus 36:1 assures us.

A SIGN OF SALVATION

This passage from Exodus is perhaps the basis of the Judeo-Christian concept of art. In the biblical account of the chosen people's flight from slavery in Egypt toward freedom in a promised land, the calling of the first artists and the building of the sanctuary are in fact conclusive acts in a series of events crucial for the history and identity of God's people—events which it will be useful to briefly recall before we proceed.

While Moses on the mountain received the tablets of the Law with the ten commandments, at the foot of the mountain his people lost confidence, fashioning a golden calf and adoring it (Exodus 32:1–6). When Moses came down, offended at the Israelites' faithlessness he shattered the tablets, obliging the people to choose between Yahweh and their idol with the words, "Those who are with the Lord follow me!" (Exodus 32:15–28). Praying, Moses obtained pardon for the people's sin and a promise that the Lord would walk in their midst.

When, however, he asked the personal privilege of seeing God, Yahweh answered: "You cannot see my face, for no human being may see me and remain alive" (Exodus 33:20). Yet God made a concession to his friend: "Behold a place near me. You will stand on the rock and when my glory passes before you, I will place you in the cavity of the rock and cover you with my hand until I have passed. Then I will remove my hand and you will see my back. But you may not see my face" (Exodus 33:21–23). Moses then ascended the mountain again and beheld, in this partial way, Yahweh who, as he passed, identified himself as "merciful and compassionate, slow to anger and rich in faithfulness." God then established a covenant with Israel, and the Ten Commandments were rewritten on other tablets (Exodus 34:1–28).

It was at this point that, descending the mountain a second time, Moses persuaded the people to make a "voluntary contribution" of all that was required for the liturgy and summoned the first of the artists, Bezaleel, declaring that Yahweh himself had "filled him with the spirit of God so that he might have wisdom, intelligence and knowledge in every kind of work, in order to conceive and realize projects in gold, silver, brass; in cutting and setting stones; in carving wood and in every sort of ingenious work" (Exodus 35:31–33).

In this sequence of events, which opens with the golden calf and closes with the ornaments of the sanctuary, it is perfectly clear that art in the service of worship is related to *sin* and *forgiveness*, becoming indeed the sign of a radical choice made by people and of God's own promise to "walk in their midst." Art in the service of worship prolongs the partial revelation of divine glory (God's back seen by Moses) and manifests the Israelites' willingness to contribute with their own means to realizing a "place near to God" whose architect in any case is God himself, who furnished the plan and endowed the artists with talent. The "voluntary contribution" required of the people in fact is an earnest of their repentance for the sin of idolatry, just as the resulting beauty of the sanctuary signals the covenant offered by Him who is "merciful and compassionate, slow to anger and rich in faithfulness, who conserves his favor for a thousand generations and pardons the offense, the transgression, and the sin" (Exodus 34:6–7). As presented in the Old Testament, that is, art becomes a privileged sign of covenant between sinful man and the God who, pardoning sin, walks with his people; it is practically a "sacrament" of the presence and salvation he offers.

CHRIST AND ART

These functions, which in ancient Israel were concentrated first in the moveable sanctuary that Moses built and then in the Jerusalem temple, might seem destined to lose significance in the new covenant instituted by Christ. Speaking to a woman of Samaria, Jesus in fact stated that neither the Samaritans' sacred mountain nor the Israelites' Temple was any longer necessary, because "the time has come—and it is now—when true worshipers will worship the Father in spirit and truth, for the Father seeks such worshipers. God is spirit," Jesus continued, "and those who worship him must do so in spirit and in truth" (John 4:21–24).

In much the same vein, one day when he was preaching, hearing people speak "of the Temple and of the beautiful stonework and votive gifts which adorned it," Jesus said: "Days are coming in which, of all that you admire here, not a single stone will escape destruction" (Luke 21:5–6). And on another occasion he used clearly provocative language to re-dimension Israel's liturgical–artistic faith, when—after expelling moneychangers and merchants from the outer courtyard—he justified his action by promising: "Destroy this temple and in three days I will make it rise again" (John 2:19).

The key to such passages is provided by the evangelist John in the verses following this assertion. Noting the astonishment of Jesus's listeners—"This temple took 46 years to build and you will make it rise again in three days?" they exclaim—, John specifies that Christ "was speaking of his body," and that "when he later rose from the dead, his disciples remembered his having said this, and believed in the Scriptures and in Jesus's words (John 2:20–22). For Christian theology in fact, the new "temple"—the "place near to God" where believers contemplate the Father's glory—is Christ himself.

In the New as in the Old Testament, mortals may not in fact see Yahweh in person, and the fourth Gospel insists that "no one has ever seen God" (John 1:17). The Gospel adds however that the only-begotten Son who dwells in the Father's bosom has revealed him (John 1:18). This assertion goes back to Christ himself, who, when the apostle Philip asked to see God, answered: "He who has seen me, has seen the Father" (John 14:9). In the same spirit, a Pauline text asserts that Christ "is the image [εικόν or icon] of the unseen God" (Colossians 1:15).

But if Christ is the incarnate "icon" of the invisible Father—the irradiation of that glory that Moses yearned to see and could not—, it follows that the role of images in the new covenant is ultimately not *less* but *more* important than in the old! The most richly decorated area of the Jerusalem Temple (as, earlier, of the "Dwelling" or "Tabernacle" fashioned by Bezaleel) was the inner cell that hosted the ark in which God's ten words were preserved on stone tablets: its walls of precious cedar carved with bunches of flowers alluded to the importance of God's words (cf. 1 Kings 6:14–18). In Jesus Christ, however, not "ten words" but *the* Word—the λόγος or *Verbum*—became flesh. He was not hidden in an arc in an inaccessible chamber, but made manifest to all, as the first letter of John insists: "That which was from the beginning, that which we have seen with our own eyes, that which we have contemplated and which our hands have touched—the Word of life (for life has become visible, we have seen it and bear witness to it and proclaim this eternal life which was with the Father but now has become visible to us): that which we have seen and heard, we proclaim to you, so that you too may be in communion with us" (1 John 1:1–3).

In the new covenant, art in fact will be a form of proclamation, meant to engender communion, of "that which was from the beginning" and which some have now experienced in

sensory fashion: have "seen," "contemplated," heard," and even "touched"—the Word incarnate, eternal life which, becoming visible, elicits the joyful testimony of those who see it. In fact, the concluding phrase of the passage just cited is: "We write these things to you so that our *joy* may be complete" (1 John 1:4).

THE SACRAMENTS AS IMAGES

In the life of the Church the designated place for expressing joy—the typical context of witnessing and communion—is the liturgy. Images made in its service thus automatically become part of a *proclamation* that is also an *encounter*, in direct analogy with the sacraments, the signs of salvation and new life instituted by Christ. It is in fact from the sacramental liturgy that sacred images draw their "power," their "presence," their "reality."

For Christian theologians of the early centuries, the sacraments were themselves considered "images." According to St. Basil, for example, in baptism (which is participation in the death and resurrection of Christ: cf. Romans 6), "the water gives us an image of death, receiving the body as a tomb would do."[2] And speaking of the Eucharist, Gaudentius of Brescia says, "the bread is properly considered an image of the body of Christ," since it is composed "of many grains of wheat" which, milled, mixed with water and baked, become an overall sign of the communion of men and women baptized in water and in the Spirit's fire—men and women who thus become the one mystical body of Christ, the Church.[3]

In these citations, the metaphorical aspect of the "image-sacrament" relationship dominates, but the Church Fathers also emphasized a specifically *visual* dimension. Leo the Great, for example, held that after Christ's return to the Father in the Ascension, "all that was visible in our Redeemer passed over

into the sacramental rites" which reveal "a mysterious series of divine actions" on which "the whole existence of the Christian is founded."[4] Such indeed is the importance of this knowledge through sensory images that Gaudentius of Brescia believed it "necessary that the sacraments be celebrated in individual churches until Christ's return from heaven, so that all—priests and laity alike—have daily before their eyes the living representation of the Lord's passion, touch it with their hands, receive it with mouth and heart and thus preserve indelibly the memory of our redemption."[5]

If the whole community should ever have Christ's passion before its eyes, however, it follows that—together with the rites that offer a "living representation" of the Savior's death and resurrection—mosaics and paintings, stained glass, and statues visualizing the contents of the rites with which they are physically associated also have singular dignity. Many works in fact suggest this relationship, a few in almost literal fashion: fifteenth-century woodcuts showing the elevation of the host at Mass celebrated before an altarpiece, for example, or sixteenth-century images showing communion being distributed in front of a "painting in the painting" which in turn depicts the body of Christ deposed from the cross. In the first instance, the faithful kneeling before an altar see themselves mirrored in the saints depicted in the altarpiece, and the host elevated by the celebrant is superimposed on the altarpiece's central figure, presumably Mary with the Christ Child. In this Eucharistic context, two truths of faith are thus made explicit: the idea of the Church as a "communion" of saints from all historical periods that itself becomes the Savior's mystical body, and the belief in a "real presence," in the bread and wine, of the same body of Christ born of the Virgin Mary.

Similar truths are conveyed by the altarpiece depicting *Saint Apollonius Giving Communion* by Girolamo Romanino (Santa

Maria Calchera, Brescia), where sacramental communion is visually linked to the body of Christ in the image shown behind the saint (a *Pietà*), and the act of "receiving the body of Christ" for which the faithful prepare themselves becomes an extension in time of the historical action of Mary, John, and the holy women who—in the painting-in-the-painting—similarly "receive" Christ's body taken down from the cross. (See figure 1.)

RITE AS IMAGE

Legitimating similar mental associations is a New Testament text, the Letter to the Hebrews, which presents Christ's whole earthly activity in liturgical terms and in its opening phrases presents images as *necessary*, an indispensable means of communicating the message of salvation. "God who in ancient times had often spoken in many ways and in many and various ways by means of the prophets, in these last days has spoken through his Son [. . .] who is the irradiation of his glory and the imprint of his substance" (Hebrews 1:1–3). Not words alone, therefore, but a *visual* experience ("irradiation"), which indeed is also *tactile* ("imprint"), are the hallmarks of the new covenant. The Son, moreover, is presented as "priest"—the definitive high priest whom the service of the ancient Levitical priesthood foreshadowed—, and "the days of his life" are described as an uninterrupted sacrificial rite, the incessant offering to God of "prayers and supplications, with loud cries and tears" (Hebrews 5:7). This "liturgy" co-extensive with the priest's life was not celebrated in an earthly sanctuary—not the tent with its decorations fashioned by Bezaleel—but in the "larger and more

Figure 1: Girolamo Romanino, 1485–1566, *Saint Apollonius Giving Communion*

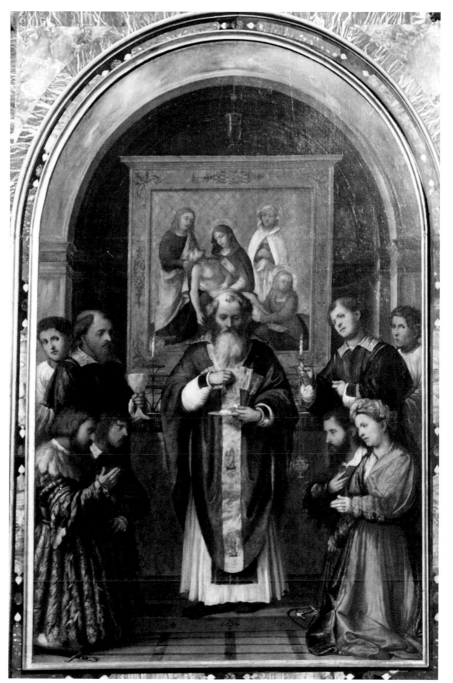

Figure 1

perfect tent, not built by human hands, that is not part of the created world" (Hebrews 9:11).

The place of sacrifice was in fact Christ's own physical body, where—as "high priest of our future blessings [. . .], not with the blood of goats and calves but with his own blood"—he entered the sanctuary "once and for all, procuring eternal salvation for us" (Hebrews 9:11–12). What is more, by penetrating to the heart of the "holy place" (of himself, that is), Christ inaugurated for all humankind "a new and living way [. . .] through the veil" that formerly separated the *Sancta sanctorum* from the outer areas of the Temple, and that "way" (road, path, route) is his *flesh* (cf. Hebrews 10:20). Offering his own life in place of the lives of ritual animals, Christ opened for us a new pathway to God.

But if the "new pathway" is the Savior's own flesh, it must be tied to his Incarnation and thus also to his visibility. Indeed, according to Athanasius Christ "built himself a temple in the Virgin—his body, that is—and, dwelling therein, made it an element in the process of his manifestation."[6] He became manifest in order to lead others along the same "pathway"—all in fact enjoy "full freedom to enter the sanctuary by means of Jesus's blood, on the new and living way which he inaugurated for us through the veil, that is his flesh" (Hebrews 10:19–20)—, and sacred images, in analogy with the sacraments that keep the memory of Christ's passion alive, serve as "road signs" for those who would walk this path. Showing Christ, Mary, and the saints in corporeal form, paintings and sculptures indicate the "new and living way" that is the Savior's flesh present in the consecrated bread but also in the "mystical body" that is the Church.

Anything but abstract, this way of reasoning is also intensely personal, for the new way to God—Christ's flesh—is also *our* flesh, and images of the body in which He celebrated the rites of an eternal priesthood are images of *our* body. "Behold in Me

your body, your limbs, your heart, your blood," Christ tells believers in an amazing page of Peter Chrysologus. "And if you fear that which is God's, why not love at least what is your own? If you flee from the Master, why not seek One to whom you are related?"[7] Moved by this idea, Chrysologus exclaims: "O immense dignity of the Christian's priesthood! Man has become both victim and priest for himself! He does not seek that which he should immolate outside himself, but bears his offering with and in his own person!" Finally, inviting his readers to imitate Christ, St. Peter Chysologus says: "Be, o man, both sacrifice and priest [. . .], make your heart an altar and thus with sure confidence present your body to God as a victim. God seeks your faith, not your death; he thirsts for your prayer, not your blood. He is placated by your willingness, not by your death."[8]

In this perspective, in addition to being a proclamation and sign of covenant, representational art in the liturgical context is also a mirror in which the Christian contemplates his own dignity, and in many images associated with the rites the Word seems really to say: "Behold in me your body, [. . .] make of your heart an altar." Such for example is the message of the painted backrest of an eleventh-century episcopal or abbatial throne in the Vatican Museum where, at the center, we see an altar adorned with a cross and—behind the altar—the risen Christ celebrating Mass. The nudity of this "priest" and his *orans* pose, with arms spread and lifted—the pose of a priest saying Mass, that is—, translate Christ's sacrifice on Calvary into ritual terms. Above this "priest-victim," a second image presents Christ as glorified, in almost literal translation of another passage in the Letter to the Hebrews, where it is asserted that Christ, "in exchange for the joy set before him, submitted to the cross despising its shame, and is now seated at the right of God's throne" (Hebrews 12:2).

Painted on the seat from which a prelate rose to go to the altar, this image communicates with extraordinary eloquence the "specular" relationship mentioned above: the bishop or abbot saying Mass must have understood that he was to have "the same mindset as Christ," acting not out of personal interest or vanity but similarly accepting the shame of the cross "in exchange for the joy set before him" (Philippians 2:3–5; Hebrews 12:2). In the same way, the faithful were meant to see Christ's body in the body of their brother—the bishop or abbot occupying the painted throne—and realize that the true "celebrant" is in fact always Christ, sole priest of the new and eternal Alliance.

Many works created for liturgical settings in fact present Christ, Mary, and the saints in the "priestly" terms of a commitment of their own lives: the famed mosaic in the basilica of San Clemente, Rome; the *Baptism of Christ* by Piero della Francesca, now in London; the next-to-last *Pietà* by Michelangelo, now in Florence (see figure 2); the *Christ Resurrected on the Cross* by Giuliano Vangi in Padua cathedral.

In all these cases, above the altar we were meant to see—at San Clemente and in Padua indeed still do see—the image of our human body offered in place of that of goats and calves, by the One who left us an example so that we might follow in his footsteps (cf. 1 Peter 2:21). In proximity to the Eucharist, even representations of the Christ Child in his mother's arms evoke the priesthood of Him who, "on entering the world" promised the Father to offer, in place of bulls and calves, the body that God had prepared for him (Hebrews 10:4–7).

Recognizing their own nature—their own humanity—in the painted or carved body of Christ or a saint, believers in fact

Figure 2: Michelangelo, 1475–1564, *Pietà*, Florence

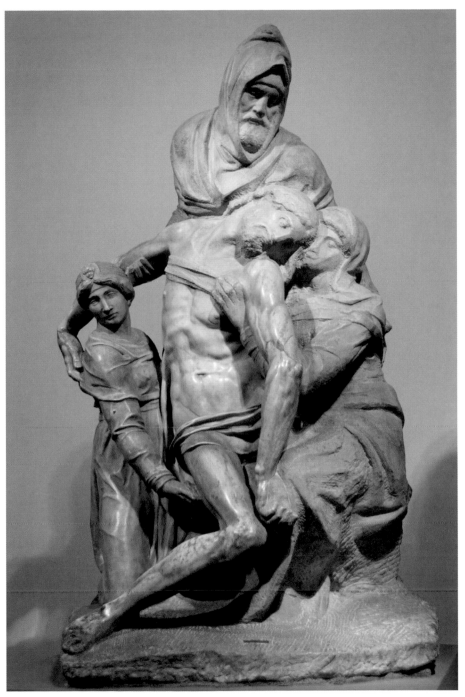

Figure 2

discover themselves "priests" and "victims" able, in Christ, to offer on the altar of their heart the sacrifice that "makes perfect, in his conscience, him who offers it" (Hebrews 9:9). Indeed, the things promised in the Old Testament—the covenant implying pardon, the nearness of God, and partial vision of his glory—become components of the experience Christians have of themselves when, in the liturgy, they encounter their Redeemer in the concreteness of human life elevated to sacerdotal dignity.

THE EARLY LITURGY AND IMAGES

All these themes are present in Christian iconography from earliest times. The continuity/discontinuity with Old Testament usages in religious worship analyzed in the Letter to the Hebrews, for example, is the theoretical "given" of a mosaic showing Abel, Abraham, and Melchisedek, situated alongside the entrance to the sanctuary in the church of Sant'Apollinare in Classe, Ravenna. (See figure 3.) A work of the sixth century, it illustrates the parallelism underlined in a contemporary liturgical text, the so-called "Roman Canon," where the celebrant asks God to direct upon the bread and wine become body and blood of Christ "your serene and benignant gaze, just as you deigned to accept the offerings of Abel, the just one, of Abraham our father in the faith, and the pure and holy sacrifice of Melchisedek, your high priest."[9]

The New Testament too—the Letter to the Hebrews—recalls these three personages in specifically liturgical roles: Abel because "he offered a sacrifice to God" (Hebrews 11:4); Abraham because "he offered Isaac" (Hebrews 11:17); and Melchisedek as the "priest of the God most high" who "blessed

Figure 3: Basilica of St. Apollinare in Classe, sixth century, Mosaic of Saints Melchisedek, Abraham, and Abel at the Altar, Ravenna

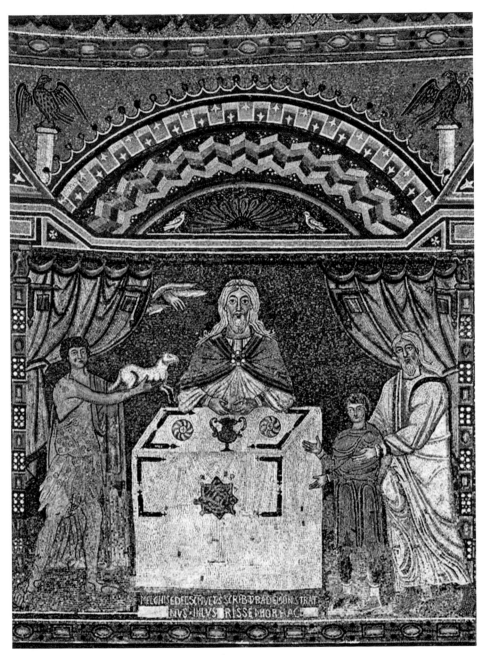

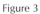
Figure 3

Abraham" (Hebrews 7:1). Thus the mosaic in Sant'Apollinare in Classe alludes to a *continuity* between the Eucharist and ancient practices used in religious worship, but at the same time to a significant element of *discontinuity*, as is suggested by the central position given Melchisedek, who in the Letter to the Hebrews is a figure of Christ: king of justice and king of peace, "without beginning of days or end of life, made like to the Son of God [. . .], eternal priest" (Hebrews 7:2–3).

In the same way, Abel and Abraham are distinguished from priests of the Jerusalem system of religious worship by the fact that—in place of calves and goats—they offer their own life: the former with "a sacrifice better than that offered by Cain," for which he would in fact be killed; the latter in Isaac, the "only-begotten son, of whom it had been said, "In Isaac you will have offspring," believing that God is able even to raise people from the dead. For this, in fact, he got him back, and it was a symbol" (Hebrews 11:17–19).

This praise of the faith of Abel and Abraham in the Letter to the Hebrews comes barely a chapter after the author's assertion of the inefficacy of the ancient system of religious worship, which "has no power to bring to perfection, by means of those sacrifices that are continually offered year after year, those who draw near to God" (Hebrews 10:1), and after the corollary statement that Christ, by offering his own blood, has inaugurated "a new and living way through the veil, that is, his flesh" (Hebrews 10:20). It should be remembered, moreover, that so emphatic a juxtaposition of animal sacrifice with Christ's offering of his own life was penned in a cultural context in which the sacrifice of bulls and goats was still universally practiced, as is suggested by a handsome Roman relief panel

Figure 4: Arch of Marcus Aurelius showing sacrifice,
second century, Capitoline Museum, Rome

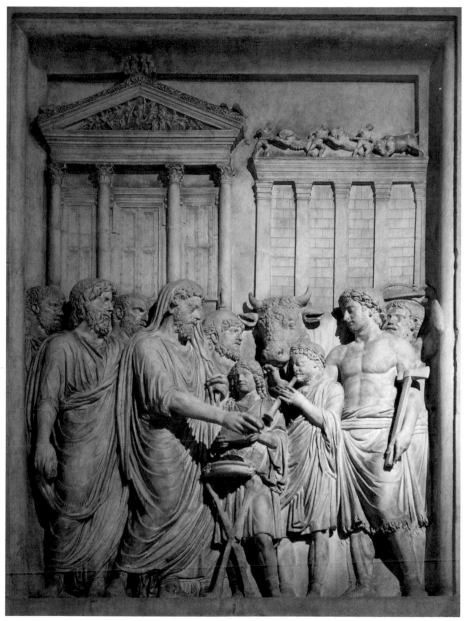

Figure 4

Figure 5

in the Capitoline Museum, in which—next to an emperor pouring incense on a brazier—we see the bull destined for sacrifice and, to the right, an acolyte ready to strike the animal with the ritual axe.[10] (See figure 4.)

THE IMAGE IN THE BREAD

The Letter to the Hebrews has influenced not only the theology but also the "iconography" of Christian liturgy, and, from the period of the mosaic in Sant'Apollinare right down to the present, the host—the unleavened bread wafer used to celebrate Mass— is normally stamped with an image that alludes to the offering of his own body accomplished by Christ when he accepted the cross. The two bread wafers on Melchisedek's altar, in the mosaic in Sant'Apollinare, for example, are stamped with small crosses which—seen in proximity to Abel's vulnerable nudity and to little Isaac presented by his father—sum up the theology of bodily sacrifice.

It is in this same spirit that an ancient stamp for producing Eucharistic bread—this too dating from the sixth century— underlined the idea of bodily offering.[11] The image was symbolic: a young deer, its antlers caught in tree branches. But the text surrounding the image, "I am the living bread descended from heaven" (John 6:51a), clearly associated this animal offering with the underlying logic of the "new and living way" of Hebrews 10. The phrase "I am the living bread" in fact concludes with the words "And the bread which I will give is my flesh for the life of the world" (John 6:51b).

From the Middle Ages to the present, the most common images stamped on Eucharistic hosts allude to Christ's offering of his own

Figure 5: Fra Bartolomeo, 1472–1517, *Christ with the "Four Evangelists,"* Galleria Palatina, Florence

body—as can be seen in numerous pictorial representations of the consecrated bread. Other objects associated with the celebration and adoration of the Eucharist similarly evoke the Savior's corporeal sacrifice—a beautiful paten (the plate for the bread offered at Mass) conserved in Siena, for example, where at the center-point meant to receive the host is an enamel *Crucifixion* scene;[12] or the Florence Cathedral *pax* with a dead Christ showing his wounds—the so-called *Imago pietatis* or *Vir dolorum*.[13]

A *pax* or *tabula pacis* was a small, portable image formerly placed on the altar. Before the communion of the Mass, at the point where today the faithful exchange a sign of peace, it was carried to those present so that each might see and kiss the Redeemer's likeness.[14] The most common subjects, the *Crucifixion, Pietà* and *Imago pietatis*, translated in literal fashion the invitation of Pope John XXII, who in a Bull issued at Avignon in 1330 asked believers to inwardly visualize Christ the Man of Sorrows during Mass, at the consecration and again at the communion.[15] Later, the iconography of Eucharistic tabernacles would often have a similar function, superimposing upon the real sacramental presence a representation meant to convey its sense through a plastic or pictorial vision of that which the believer's eye in fact sees only in mystery.[16]

A SCHOOL OF CONTEMPLATION

This visionary dimension was more than mere substitution and did not limit itself to furnishing images of the invisible realities to which the sacraments refer, but functioned as a "school of contemplation." An especially clear example is the large altarpiece executed around 1516 for a Marian sanctuary in Florence, the church of Santissima Annunziata: the so-called *Salvator mundi* of Fra Bartolomeo, now in Palazzo Pitti.[17] (See figure 5.) The

painter, a Dominican friar, shows the risen Christ on a pedestal giving a blessing and surrounded by the four evangelists. In the work's original position, the faithful would have seen the bread and wine elevated by the celebrant at Mass against the backdrop of Fra Bartolomeo's risen, white-clad Christ, in whose hands and side they could also see the wounds of the crucifixion. It is hard to imagine that anyone entirely missed the point that the Eucharist makes present on the altar the body and blood of the One who died on the cross and then rose for all humankind.

Beneath Christ's feet—in front of the pedestal depicted in the altarpiece and directly in front of the living priest as he said Mass—there is something quite unusual: a chalice and paten above a plaque which in turn is set above a convex mirror. The mirror is as round as a globe, and on the plaque are the words *Salvator mundi*, "Savior of the world"; reflected in this mirror we in fact see "the world": sky, mountains, a plain, a city (Florence). Thus, if we once again imagine the painting's original context of use, it is evident that the mirror reflecting the world was right in front of the bread and wine in the hands of the celebrant, who must thus have grasped that these elements deriving from the earth in fact symbolize "the world" which, together with humankind, is called to salvation. Even when Mass was not being celebrated before the painting, the chalice and paten above "the world" conveyed that "creation itself [. . .] nurtures the hope of being freed from the slavery of corruption and enjoy the liberty of the glory of the sons of God" (Romans 8:19–21).

Yet there is still more. In theological terms, "the world" is represented not only by the bread and wine come from the earth and offered in the Eucharistic signs, but also by Christ's body, which Fra Bartolomeo shows us above the chalice and paten. In a text that the Dominican painter could easily have known, Augustine's *Commentary on Psalm 98*, it is averred that "Christ

took earth from the earth, assuming flesh from the flesh of Mary. And since he walked the world in that flesh, and then gave it to us for our salvation, and since no one should eat his flesh without first adoring it," Christians should "adore" the earth too, intimately associated with the divinity of Christ by virtue of the fact that he took his body from a human body nourished by the earth (from the body of Mary, that is, fed with things come from the earth). In that body—in that "earth"—Christ died and rose in order to make himself physically present in elements drawn from the earth, bread and wine.[18]

CREATED THINGS AND THE MOTHER

Similar musing on the relationship between the Eucharist and the created world invites us more generally to ponder the sense of "things" in a sacramental context. It invites us, for example, to see the gold and mineral-based enamels of the Siena paten as elements of a redeemed world, and the flowers that the goldsmith arranged around Christ's cross in the central area destined to receive the host as the expression of a cosmic mysticism described in antiquity by the phrase: "The earth has yielded its fruit" (Psalm 67:7). It invites us above all to ponder the relationship between the Eucharist and the human being in whom—quite literally— the earth yielded its fruit: the woman from whom Christ took the flesh which he later offered for humankind in the sign of bread, Mary.

Indeed, for a thousand years the most common Christian image in the Eucharistic context, at times even stamped on the host, was that of Mary with her Child.[19] When at the offertory and

Figure 6: Anonymous, fifteenth century, Mary breastfeeding her Babe, Santuario Eremo, Greccio

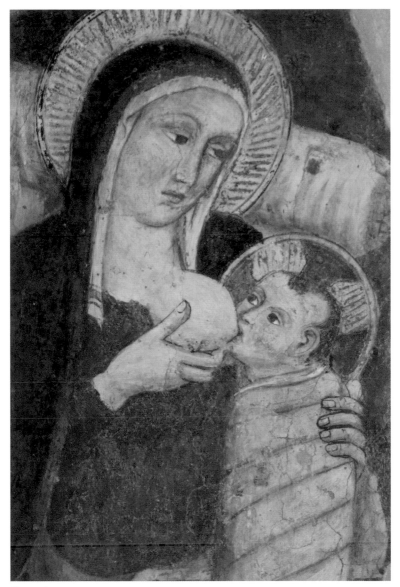

Figure 6

consecration a priest elevated the host before a representation of the Child's body in his mother's arms, it was easy to understand Leo the Great's assertion that "the only purpose of the birth of God's Son was to make the crucifixion possible; in the Virgin's womb he assumed mortal flesh, and in that flesh brought his passion to fulfillment."[20]

Mary's whole life came to be associated with the Eucharist, and from the twelfth through the sixteenth centuries iconographical programming in churches and chapels often placed the Annunciation scene on the arch leading into the altar area, the archangel Gabriel to the viewer's left and the Virgin to the right, so that the intermediate space (the space in which the altar was situated) became a metaphor for the womb in which, under the power of the Holy Spirit, Christ was conceived. This arrangement is illustrated in a small fourteenth-century Sienese tabernacle at Castelnovo Berardenga (Badia a Ombrone), where the Eucharistic receptacle—located between the announcing angel and the Virgin to whom the announcement is made—is perceived as the "space of the Incarnation" in which "body" and "bread" are one and the same.[21]

So too Augustine's mystically circular argument, which we associated with Fra Bartolomeo's altarpiece, has a specifically Marian version. At Greccio, in the fresco of an anonymous fifteenth-century painter in the grotto where—in the early thirteenth century—St. Francis had "invented" the Christmas crèche, Mary is shown breastfeeding her Babe. (See figure 6.) Situated above the exact center of a Eucharistic altar—that is, at the point where the priest consecrates the bread and wine—, this breastfeeding woman perfectly expresses the mystery of earth which nourishes the physical life transmitted by milk which in turn forms the flesh of Mary's Son—flesh which, offered on the cross, becomes bread of eternal life.

The liturgical origin of an image, indeed, almost always invites multiple and fluid readings. In the Greccio fresco, for example, the above-suggested mystical sense of the image does not contradict but rather completes the more literal one of maternal love communicated by the tender relationship between Mary and her Baby. In the same way, the Child's swaddling bands and the manger shaped like a sarcophagus—clear allusions to Jesus's future death—do not contradict but rather intensify other levels of meaning. It is as if we were looking simultaneously at two distinct horizons: one nearby, defined by a mother's love and the cloth bands in which all babies were formerly wrapped; and another, distant and mysterious, alluding to the earth, nurse of a God who, dying, became bread.

This perceptual mobility—this to-and-fro movement from one world of ideas to another along an emotional border continually changing alignment—springs from the lived experience of the Sacraments and of Scripture—or, more precisely, of Scripture proclaimed in a sacramental context. The allusion to the newborn Jesus's future death in the Greccio fresco, for example—or in a small diptych attributed to Simone Martini in the Horne Museum, Florence, where Mary holds the Child in her arms even as she contemplates him as an adult who has died—, derives from the New Testament, where the accounts of Christ's infancy contain repeated allusions to his future death. "Allusion" then becomes "image" thanks to the liturgy, which—with mystical fluidity—even on Christmas night remembers and lives the words pronounced another night: "This is my body, this is my blood."

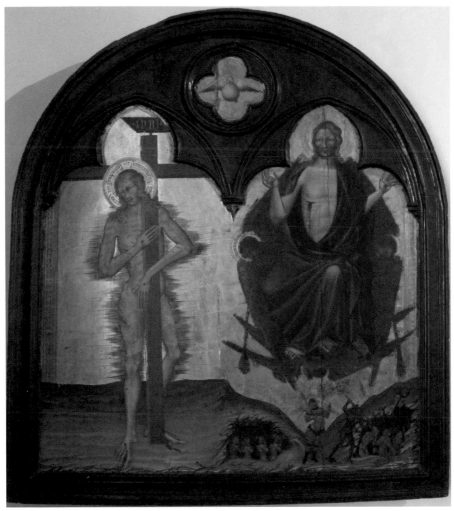

Figure 7

AWAITING TRANSFORMATION

As in the liturgy so in images tied to the liturgy, believers are invited to seek—beyond that which they see—something more, perhaps not seen because still in the future or hidden—something which in any case radically alters the sense and aspect of things seen. The image thus offers itself as both "epiphany" and "apocalypse"—as manifestation and as revelation: such is the character of the already mentioned Sienese diptych showing the lively Christ Child at the left and the same, a dead adult, at right, and of such materially "epiphanic" works as stratified altarpieces, which, as they are opened, disclose ever new combinations of images. It is the case of the "cupboard Madonnas" of the later Middle Ages, which outside show only the Virgin and Child, but when opened reveal Christ on the cross, the Father, the Spirit, the faithful—as if to assert that in the Incarnation are already contained the mysteries of the Trinity and of the Church, Christ's mystical body of which Mary remains mother.

Radical transformation in a liturgical context is the theme of a splendid Sienese altarpiece by Giovanni di Paolo, in which we see the humiliated Christ bearing his cross, on the left, while at the right, resurrected and triumphant he judges the living and the dead, showing his wounds as trophies. (See figure 7). In between—between the *imago pietatis*, and the *imago gloriae*, that is—we see the Holy Spirit, worker of the transformations that lead to eternal life (including the Eucharistic one: the "change" of bread and wine into the Savior's body and blood). The symbolic dove is located at the apex of the image, above the point where the priest invoked the Spirit at the consecration, and it is as if the third Person of the Trinity were descending simultaneously on the

Figure 7: Giovanni di Paolo, 1398–1482, *Longsuffering Christ and Christ the Judge,* Pinacoteca Nazionale, Siena

suffering Christ to raise him to glory, and on the bread and wine to transform their substance.

When Mass was still said before this altarpiece, the host and chalice elevated between the two representations of Christ further conveyed that, just as Christ rose *in* the Spirit and *under* the Spirit bread becomes his body, so too those who eat this bread are destined to be transformed. "As once we bore the image of the earthly man, so we will bear that of the heavenly [. . .]: in an instant, in the twinkling of an eye, at the sound of the last trumpet [. . .] we shall be transformed" (1 Corinthians 15:49–52).

In its sacramental theory and practice, from early Christian times onward the Church has taught believers to expect such a transformation and to see in it the fulfillment of God's plan. Commenting on the "sign" of water turned into wine at Cana, Faustus of Rietz said: "The water is suddenly transformed, and it will later transform men"; he moreover specified that "when one thing springs from another by an internal process, or when an inferior creature is, by a secret conversion, lifted to a higher state, we see a second birth."[22]

This "second birth" is in essence a new life, for—as Gregory of Nyssa teaches—"our very nature has undergone a change" such that we have "a different life and a different way of living."[23] In the same vein, Cyril of Alexandria says: "the Spirit transforms those in whom he dwells into another image, as it were," and cites St. Paul, according to whom "all of us, with uncovered visage and reflecting the Lord's glory as in a mirror, will be transformed in that same image, from glory to glory, according to the action of the Spirit" (2 Corinthians 3:18).[24]

My point is this: art associated with the liturgy illuminates a fundamental expectation of believers, announcing a longed-for spiritual transformation by its own transformation of matter.

More importantly, sacred images mirror—in the personages and events they illustrate—that Image in which believers themselves hope to be transformed, and indeed in this "specular" logic an artwork's iconographical subject is not confined to the personage or event represented, but always includes those who contemplate their own lives in the image even as they await transformation. Such "intersubjectivity," moreover, regards both individuals and groups, the few worshipers present at daily Mass and the parish community fully assembled on Sundays and feasts. All are "edified"—inwardly *built up*—by images seen as they hear Mass, because in that situation the images are not merely "seen" (just as the Mass is not merely "heard"), but rather *taken part in* and *lived* in ever new intersubjective configurations. The Baroque altarpieces of Antwerp Cathedral, like the neo-Byzantine icons in a contemporary church, in fact open fresh and continually changing perspectives on the sense of the words and actions of the liturgies celebrated before them. Even when images may not be to our taste, or are qualitatively inferior, in the liturgical context they are rarely without effect, for the believer—learning "not to look upon the Eucharistic bread and wine as if these were simple, common elements"[25] but to await "new and extraordinary changes"[26]—, also learns to look beyond the images, whether beautiful or ugly, certain to one day possess that which, for the present, art lets him only see.

*Author's translation of "Il genio artistico della liturgia," the introductory chapter of T. Verdon, *Vedere il mistero. Il genio artistico della liturgia cattolica* (Milan: A. Mondadori, 2003), 13–35.

Notes:

1 Literature on this theme is copious, but useful for the present study have been: M. Righetti, *Manuale di storia liturgica*, third edition, Milano 1964 (edizione anastatica 1998), 4 vol.; C. Vagaggini, *Il senso teologico della liturgia. Saggio di liturgia teologica generale*, Roma 1957; J. Jungmann, S.I., *The Early Liturgy to the Time of Gregory the Great*, Notre Dame, Indiana 1959; G. Van der Leeuw, *Sacred and Profane Beauty: The Holy in Art,* trans. D. E. Green, New York 1963; L. Bouyer, *Eucharistie: théologie et spiritualité de la prière eucharistique,* Paris 1966; J.M. Powers, *Eucharistic theology*, New York 1967; H. U. Von Balthasar, *Gloria: Una estetica teologica*, 6 vol., Milan 1971; T. Klauser, *La liturgia della Chiesa occidentale: Sintesi storica e riflessioni,* Turin 1971; M.-D. Chenu, "Pour une anthropologie sacramentale," in *La Maison Dieu* 3 (1974): 85-100; B. Cooke, *Ministry to Word and Sacraments: History and Theology*, Philadelphia 1977; C. Jones, G. Wainwright, E. Yarnold, S.I. (ed.), *The Study of Liturgy*, New York 1978 (with important essays by P.G. Cobb, "The History of the Christian Year," 403-418, and "The Architectural Setting of the Liturgy," 473-487; K. Donovan, S.I., "The Sanctoral," 419-431; H. Wybrew, "Ceremonial," 432-439); L.M. Chauvet, *Du symbolique au symbole. Essai sur les sacrements*, Paris 1979; D. Sartore, "Panoramica critica del dibattito attuale sulla religiosità popolare," in AA.VV., *Liturgia e religiosità popolare. Proposte di analisi e orientamenti (Atti della VII settimana di studio dell'Associazione dei professori di liturgia)*, Bologna 1979, 17–50; L. Maldonado and D. Power, (eds.), *Symbol and Art in Worship*, New York, 1980; D. Power, *Unsearchable Riches: The symbolic Nature of Liturgy,* New York 1984; B. Neunheuser, *Storia della liturgia attraverso le epoche culturali*, seconda edizione, Roma 1983; D. Sartore, A.M. Traicca (ed.), *Nuovo Dizionario di liturgia*, Roma 1984; E. Lodi, E. Ruffini, *"Mysterion" e "Sacramentum". La sacramentalità negli scritti dei Padri e nei testi liturgici primitivi* ("Nuovi saggi teologici 24"), Bologna 1987; R. Tagliaferri, "Modelli di comprensione della scienza liturgica," in *Il mistero celebrato. Per una metodologia dello studio della liturgia (Atti della XVII settimana dell'Associazione dei Professori di Liturgia, Assisi 1988),* Roma 1989, 19-102; P.E. Fink, S.I. (ed.), *The New Dictionary of Sacramental Worship*, Collegeville, Minnesota 1990; C. Valenziano, *Liturgia e* antropologia, Bologna 1997; V. Gatti, *Liturgia e arte. I luoghi della celebrazione*, Bologna 2001 (with an ample bibliography); T. Verdon, *L'arte sacra in Italia,* Milano 2001.

2 *Trattato sullo Spirito Santo*, 15:35. J. P. Migne, *Patrologiae cursus completus, series graeca* (=PG), 242 vols., Paris 1857-66 : 32, 130–31.

3 *Trattato 2. Corpus scriptorum ecclesiasticorum latinorum* (=CSEL), Vienna 1866ss: 68, 30–32.

4 *Discorso 2 sull'Ascensione*, 1:4. J. P. Migne, *Patrologiae cursus completura, series latina* (=PL), 221 vol, Paris 1844-64:54, 397–99.

5 *Trattato 2*, cit. (nota 3).

6 *Discorso sull'incarnazione*, 8–9. PG 25, 110–111.

7 *Discorso 108*. PL 52, 499–500.

8 Ibid.

9 Sacra Congregazione per il culto divino e Conferenza episcopale italiana, *Messale romano*, Città del Vaticano 1983, 390.

10 *Cambridge Ancient History*, vol. V, Cambridge 1939, 104; I.S. Ryberg, *Rites of the Roman State Religion* (*Memoirs of the American Academy*, 22), Roma 1955, 156ss.

11 Righetti, *Manuale*, cit. (nota 1), 3:585. Cfr. J. Corblet, *Histoire dogmatique, liturgique et archéologique du Sacrement de l'eucharistie*, Paris 1886, 189; H. Leclercq, "Fer à hostie," in F. Cabrol, H. Leclercq, *Dictionnaire d'Archéologie chrétienne et de Liturgie*, Paris 1907–1953, cc. 1347ss.; R. M. Wooley, *The Bread of the Eucharist*, London 1913; L. Vloberg, *L'Eucharistie dans l'art*, Paris 1946.

12 Cf. *Panis vivus. Arredi e testimonianze del culto eucaristico dal VI al XIX secolo*, Catalogo della mostra svoltasi a Siena dal 21 maggio al 26 giugno del 1994, ed. C. Alessi e L. Martini, Siena 1994, 76–82.

13 Cf. *La Chiesa e la città a Firenze nel XV secolo*, Catalogo della mostra svoltasi a Firenze dal 6 giugno al 6 settembre del 1992, a cura di G. Rolfi, L. Sebregondi, P. Viti, Firenze 1992, 191–193.

14 F. Rossi, "Paci fiorentine del XV-XVI secolo: da sant'Antonino al Concilio di Trento," e S. Tesi, "Paci fiorentine della Controriforma," due tesi di laurea della Facoltà di Lettere, Università di Firenze, discusse nel luglio 1997, con esaustiva bibliografia.

15 C. Eisler, "The Golden Christ of Cortona and the Man of Sorrows in Italy," in *The Art Bulletin* 51 (1969), 107–118 and 235–246: 235.

16 U. Middeldorf, "Un rame inciso del Quattrocento," in *Scritti di storia dell'arte in onore di Mario Salmi*, II, Roma 1962, 273ss.

17 T. Verdon, "'Dimorava quasi continuamente in convento': fra Bartolomeo e lo stile di San Marco," in *La vocazione artistica dei religiosi* (*Arte cristiana* 82: 1994) 389–398.

18 *Ennaratio in Psalmo 98*: PL 37, 1264.

19 Righetti, *Manuale*, cit. (nota 1), 3:585.

20 Leone Magno, *Trattato 48,1: Corpus christianorum latinorum* (=CCL) 138A :279–80.

21 Cfr. *Panis vivus*, cit. (nota 12), 229.

22 *Discorso 5 sull'Epifania*. PL supplementum 3, 560–62.

23 *Discorso sulla Risurrezione di Cristo 1*. PG 46, 603–606.

24 *Commento al Vangelo di Giovanni 10*. PG 74, 434.

25 *Le catechesi di Gerusalemme*, 22. PG 33, 1098–1106.

26 Teodoro lo Studita, *Discorso sull'adorazione della croce*. PG 99, 691–699.

ARTWORK AND PHOTOGRAPHY PERMISSIONS

INTRODUCTION:
Timothy Verdon

Figure 1: Pieter Neefs the Elder, *Antwerp Cathedral*, © Victoria and Albert Museum, London.

Figure 2: Pieter Jansz. Saenredam, Detail, *Interior of the Sint-Odulphuskerk*, 1649. Rijksmuseum Amsterdam. [Public domain], via Wikimedia Commons.

CALVIN AND THE VISUAL ARTS:
Jérôme Cottin

Figure 1: Rembrandt: *The Company of Frans Banning Cocq and Willem van Ruytenburgh*, known as *The Night Watch*. Rijksmuseum Amsterdam. [Public domain], via Wikimedia Commons.

Figure 2: Johannes Vermeer, *The Girl with a Wineglass*. [Public Domain], Herzog Anton Ulrich Museum.

Figure 3: Ruud Morijn, photographer, historic Dutch church. Used by permission.

Figure 4: Vincent Van Gogh, *Fishing Boats on the Beach at Les Saintes-Maries-de-la-Mer*. Pushkin Museum. [Public Domain].

OPENING THE PROTESTANT CHURCH TO BEAUTY:
William Dyrness

Figure 1: Anonymous, *The Last Supper* c. 1581, Haarlem, Great or St. Bavo Church. Courtesy of Mia Mochizuki (Photo: Tjeerd Frederikse).

Figure 3: Jacob van Ruisdael, *Three Great Trees in a Landscape*, 1667. Norton Simon Museum, Pasadena, California (Image courtesy of the Norton Simon Foundation.)

Figure 4: Mosaic Apse, "Christ in Glory." Helen McLean, design; Alessandra Caprara, mosaic. © 2006 Orleans Church Building Foundation, Inc.

Capitals, Interior of Church. The Community of Jesus, design; Régis Demange, sculpture. © 2004 Orleans Church Building Foundation, Inc.

Frescoes, North and South Walls. Silvestro Pistolesi, fresco. ©
2003-2012 Orleans Church Building Foundation, Inc.
Photograph used by permission. © 2012 The Community of
Jesus, Inc., All rights reserved.

FOR NOW WE SEE THROUGH A GLASS, DARKLY:
Susan Kanaga

Figure 1: Atrium Lintel "Ruach." Susan Kanaga, The Community of Jesus,
design; Régis Demange, sculpture. © 2004 Orleans Church
Building Foundation, Inc.
Photograph used by permission. © 2012 The Community of
Jesus, Inc., All rights reserved.

Figure 2: Susan Kanaga, *Yes* triptych. Used by permission of the artist.

Figure 3: Susan Kanaga, *Journey* triptych. Used by permission of the artist.

Figure 4: Susan Kanaga, *Messengers*. Used by permission of the artist.

Figure 5: Central installation from *Frammenti* exhibition, 2015, a
collaboration between Susan Kanaga and Filippo Rossi. Shown
here: suspended shoes, detail of *Fragmented Figure*. Used by
permission of the artist.

Figure 6: Central installation from *Frammenti* exhibition, 2015, a
collaboration between Susan Kanaga and Filippo Rossi. Shown
here: Susan Kanaga, suspended sculpture *Fragmented Figure*;
Filippo Rossi: *Floor Cross*. Used by permission of the artists.

Figure 7: Susan Kanaga, *Tree of Mercy, Tree of Life*. Used by permission of
the artist.

FOTIS KONTOGLOU:
Vasileios Marinis

Figure 1: George Kordis, *Presentation in the Temple*. Church of Zoodochos
Pege, Paiania, Greece. Used by permission of the artist.

Figure 2: George Kordis, *The Martyrdom of St. Loukia*. Rio, Patras, Greece.
Used by permission of the artist.

THE ARTIST AS CONTEMPLATIVE:
Filippo Rossi

Figure 1: © 2008 Filippo Rossi, *Magnificat*, Church of the Transfiguration, Orleans, MA.

Figure 2: © 2008 Filippo Rossi, detail, *Magnificat*, Church of the Transfiguration, Orleans, MA.

Figure 3: Filippo Rossi, *Re-Velation*. Used by permission of the artist.

Figure 4: Filippo Rossi, *At the Heart of Glory*. Used by permission of the artist.

Figure 5: Filippo Rossi, *The Price*. Used by permission of the artist.

Figure 6: Filippo Rossi, *Gemmed Cross*. Used by permission of the artist.

Figure 7: Filippo Rossi, *Column of Faith*. Used by permission of the artist.

Figure 8: Filippo Rossi, *Column of Faith*, detail. Used by permission of the artist.

BEAUTY IN AND OF THE CHURCH:
Martin Shannon

Figure 1: The Church of the Transfiguration, Orleans, MA. Photographer, Robert Benson, © 2011 Robert Benson Photography. Used by permission.

Figure 2: The Church of the Transfiguration, Orleans, MA. Frescoes, North and South Walls. Silvestro Pistolesi, fresco. © 2003-2012 Orleans Church Building Foundation, Inc.
Capitals, Interior of Church. The Community of Jesus, design; Régis Demange, sculpture. © 2004 Orleans Church Building Foundation, Inc.
Photograph used by permission. © 2012 The Community of Jesus, Inc., All rights reserved.

Figures 3 and 4: The Church of the Transfiguration, Orleans, MA. Mosaic Floor: Font, Processional Path, Medallions. Helen McLean, design; Alessandra Caprara, mosaic. © 2004-2005 Orleans Church Building Foundation, Inc.
Mosaic Sanctuary Floor. The Community of Jesus, design; Alessandra Caprara, mosaic. © 2010 Orleans Church Building Foundation, Inc.
Mosaic Apse, "Christ in Glory." Helen McLean, design; Alessandra Caprara, mosaic. © 2006 Orleans Church Building Foundation, Inc.
Frescoes, North and South Walls. Silvestro Pistolesi, fresco. © 2003-2012 Orleans Church Building Foundation, Inc.
Capitals, Interior of Church. The Community of Jesus, design; Régis Demange, sculpture. © 2004 Orleans Church Building Foundation, Inc.

Processional Cross. The Community of Jesus, design; Robert Jordan, fabrication. © 2004 Orleans Church Building Foundation, Inc.

Altar Mensa. Helen McLean, design: Régis Demange, sculpture. © 2004 Orleans Church Building Foundation, Inc.

Ambo Desk. Helen McLean, design; Romolo Del Deo, sculpture. © 2004 Orleans Church Building Foundation, Inc.

Photograph used by permission. © 2012 The Community of Jesus, Inc., All rights reserved.

Figure 5: The Church of the Transfiguration, Orleans, MA. West Wall, "Transfiguration." Architectural glass sculpture: Gabriele Wilpers, design; Derix Glass Studios, fabrication. © 2010 Orleans Church Building Foundation, Inc.

Oculus Window. Helen McLean, design and fabrication. © 2004 Orleans Church Building Foundation, Inc.

Photograph used by permission. © 2012 The Community of Jesus, Inc., All rights reserved.

ART AND THE LITURGY:
Timothy Verdon

Figure 1: Girolamo Romanino: *Saint Apollonius Giving Communion*. Chiesa di S. Maria in Calchera, Brescia. Luca Giarelli - Opera propria, CC BY-SA 4.0, https://commons.wikimedia.org/w/index.php?curid=40141617.

Figure 2: Michelangelo: *Pietà*. Museo dell'Opera del Duomo, Florence. © Marie-Lan Nguyen / Wikimedia Commons / CC-BY 2.5.

Figure 3: Basilica of St. Apollinare in Classe. Mosaic of Saints Melchisedek, Abraham and Abel at the Altar, Ravenna.

Figure 4: Bas relief from Arch of Marcus Aurelius showing sacrifice. Capitiline Museum, Rome. https://de.wikipedia.org/wiki/Benutzer:MatthiasKabel.

Figure 5: Fra Bartolomeo, *Christ with the Four Evangelists*. Oil on canvas, 282 x 204 cm, Galleria Palatina (Palazzo Pitti), Florence. http://www.wga.hu/preview/b/.

Figure 6: Anonymous, early thirteenth-century fresco showing the Virgin Mary breastfeeding, Santuario Eremo di Greccio (Ri). Used by permission of Matteo Bimonte, photographer.

Figure 7: Giovanni di Paolo (1402–1483), *Longsuffering Christ and Christ the Judge*. Pinacoteca Nazionale, Siena. By Combusken (Own work) [CC BY-SA 3.0 (http://creativecommons.org/licenses/by-sa/3.0)]

ABOUT PARACLETE PRESS

WHO WE ARE

Paraclete Press is a publisher of books, recordings, and DVDs on Christian spirituality. Our publishing represents a full expression of Christian belief and practice—from Catholic to Evangelical, from Protestant to Orthodox.

We are the publishing arm of the Community of Jesus, an ecumenical monastic community in the Benedictine tradition. As such, we are uniquely positioned in the marketplace without connection to a large corporation and with informal relationships to many branches and denominations of faith.

WHAT WE ARE DOING

Paraclete Press Books

Paraclete publishes books that show the richness and depth of what it means to be Christian. Although Benedictine spirituality is at the heart of who we are and all that we do, we publish books that reflect the Christian experience across many cultures, time periods, and houses of worship. We publish books that nourish the vibrant life of the church and its people.

We have several different series, including the best-selling Paraclete Essentials and Paraclete Giants series of classic texts in contemporary English; Voices from the Monastery—men and women monastics writing about living a spiritual life today; our award-winning Paraclete Poetry series as well as the Mount Tabor Books on the arts; best-selling gift books for children on the occasions of baptism and first communion; and the Active Prayer Series that brings creativity and liveliness to any life of prayer.

Mount Tabor Books

Paraclete's newest series, Mount Tabor Books, focuses on the arts and literature as well as liturgical worship and spirituality, and was created in conjunction with the Mount Tabor Ecumenical Centre for Art and Spirituality in Barga, Italy.

Paraclete Records

From Gregorian chant to contemporary American choral works, our recordings celebrate the best of sacred choral music composed through the centuries that create a space for heaven and earth to intersect. Paraclete Recordings is the record label representing the internationally acclaimed choir Gloriæ Dei Cantores, praised for their "rapt and fathomless spiritual intensity" by *American Record Guide*; the Gloriæ Dei Cantores Schola, specializing in the study and performance of Gregorian chant; and the other instrumental artists of the Arts Empowering Life Foundation.

Paraclete Press is also privileged to be the exclusive North American distributor of the recordings of the Monastic Choir of St. Peter's Abbey in Solesmes, France, long considered to be a leading authority on Gregorian chant.

Paraclete Video Productions

Our DVDs offer spiritual help, healing, and biblical guidance for a broad range of life issues including grief and loss, marriage, forgiveness, facing death, bullying, addictions, Alzheimer's, and spiritual formation.

Learn more about us at our website
WWW.PARACLETEPRESS.COM
In the USA phone us toll-free at 1.800.451.5006;
outside the USA phone us at +1.508.255.4685

SCAN
TO
READ
MORE

THE STORY OF
ST. FRANCIS OF ASSISI
IN TWENTY-EIGHT SCENES

Timothy Verdon

$24.99 | 978-1-61261-685-8 | Hardcover

This beautiful new book by renowned art historian Timothy Verdon tells the story of the life of St. Francis of Assisi in story and art. The 28 stunning thirteenth-century frescoes by Giotto that cover the walls of the famous Basilica in Assisi named for the saint are reproduced in full color, together with a schematic drawing showing their placement in the church. Through detailed descriptions and illuminating commentary on each of the famous frescoes, Verdon tells the story of Francis's extraordinary life, allowing today's reader the opportunity to "read" the art on those walls in the same way that a medieval Christian might have done.

Available through your local bookseller or through Paraclete Press:
www.paracletepress.com; 1-800-451-5006

A WELL OF WONDER

Essays on C. S. Lewis, J. R. R. Tolkien, and the Inklings

Clyde S. Kilby, Edited by Loren Wilkinson and Keith Call

$28.99 | 978-1-61261-861-6 | Hardcover

This is the first of two volumes that introduces Christians to the reflections of **Clyde S. Kilby**, late professor of English at Wheaton college. Kilby founded the Marion C. Wade Center, which eventually housed the writings of C. S. Lewis, J. R. R. Tolkien, G. K. Chesterton, Dorothy Sayers, Charles Williams, George MacDonald and Owen Barfield. The author writes lovingly and knowingly about the Inklings and related writers and gives new insights into their lives and work.

THE ARTS AND THE CHRISTIAN IMAGINATION

Essays on Art, Literature, and Aesthetics

Clyde S. Kilby, Edited by William Dyrness and Keith Call

$28.99 | 978-1-61261-861-6 | Hardcover

This collection offers a sampler of the work of **Clyde S. Kilby** on these themes: "Christianity, the Arts, and Aesthetics"; "The Vocation of the Artist"; "Faith and the Role of the Imagination"; and "Poetry, Literature, and the Imagination." With a unique voice, Kilby writes from a specific literary and philosophical context that relates art and aesthetics with beauty, and all that is embodied in the classics. His work is particularly relevant today as these topics are being embraced by Protestants, Evangelicals, and indeed people of faith from many different traditions. A deeply engaging book for readers who want to look more closely at themes of art, aesthetics, beauty, and literature in the context of faith.

Available through your local bookseller or through Paraclete Press:
www.paracletepress.com; 1-800-451-5006